MALTING AND MALTHOUSES IN KENT

JAMES M. PRESTON

AMBERLEY

First published 2015

Amberley Publishing
The Hill, Stroud,
Gloucestershire, GL5 4EP

www.amberley-books.com

Map illustration by Thomas Bohm, User Design, Illustration and Typesetting.

ISBN: 978 1 4456 5306 8 (print)
ISBN: 978 1 4456 5307 5 (ebook)

British Library Cataloguing in Publication Data.
A catalogue record for this book is available from the British Library.

Typeset in 10pt on 13pt Celeste.
Typesetting by Amberley Publishing.
Printed in the UK.

Contents

Introduction

The first information about ale drinking in Britain comes from the Greek historian Diodorus Siculus of Sicily, writing between 60 and 30 BC, who stated that Britons drank a 'fermented liquor' made from barley when feasting. Pedanius Dioscorides, the Greek physician writing between AD 40 and 90, also commented on a barley-based beverage consumed by Britons, which he described as 'headachy, unwholesome, and injurious to the nerves'. Evidence for malting in Roman Kent comes from the partial excavation of a building in Nonington, where a concentration of malted spelt wheat was uncovered although the excavation was not extensive enough to reveal an oven or drying kiln. Ale, consumed by all classes from the Dark Ages onwards, was a safe drink that was laden with calories in which the water, otherwise of doubtful reliability, was boiled. Most brewing and associated malting was carried on at a domestic level into the Middle Ages, when larger scale brewing developed at taverns and particularly at monasteries, which provided hospitality to pilgrims and travellers. Excavations in 1993 at St Augustine's Abbey, Canterbury, revealed a brew house, together with a possible malthouse, newly built by Abbot Thomas Fyndon between 1283 and 1309 to cater for pilgrims travelling to the shrine of Thomas Becket. Manor complexes had maltings and brew houses, with, for instance, excavations at Randall Manor, Shorne, uncovering a late thirteenth-century brew house with an associated malt oven.

By the early fifteenth century, hops, which gave flavour and acted as a preservative, had been introduced into brewing, giving rise to the term 'biere' or 'beere' and distinguishing it from ale. The growth in the scale of breweries and the number of brewers was recognised in 1406 by the London brewers being constituted into 'The Mistery of Free Brewers', and their gaining a charter in 1437 from Henry VI as the 'Brewers' Company', thereby underlining the importance of the London market. The number of large commercial brewers increased rapidly from the sixteenth century in London, the larger towns and in the ports. By the beginning of the nineteenth century brewing was the third largest industry in Britain, with numbers nationally reaching 16,798 by 1881. These developments all gave rise to a commensurate increase in the production of malt, for which Kent, in the late sixteenth and seventeenth centuries, was well placed geographically to supply the dominant London brewers.

1

The Supply of Barley and Trade in Malt

Barley has been cultivated in Kent since pre-Roman times, mainly for malting for the brewing of ale, but also, to a lesser extent, as animal fodder. The best soils for barley cultivation were the rich deep loams between Gillingham and Faversham, and the mixed loam and lighter chalk soils of east Kent, particularly in Thanet. Barley cropped well on the chalky soil of the Downs. William Ellis in the *London and Country Brewer* (1736) stated 'all the Chalks are better ... Barley acquires a whitish Body, a thin skin, a short plump kernel ... which occasion those fine pale and amber Malts'. The lighter soils of the sandstone ridge running from Sevenoaks to Folkestone were also suitable for the cultivation of barley.

However, the importance of barley as a crop in some parts of Kent diminished, with change becoming perceptible at the end of the seventeenth century. The shift to more profitable crops was commented upon by observers. Celia Fiennes, in 1697, noted the 'great Hopyards' on both sides of the road from Sittingbourne to Canterbury, between Maidstone and Rochester, and the cherry orchards between Rochester and Gravesend, which supplied fruit to the London market. In 1724 Defoe commented on the Maidstone area producing cherries, apples and hops for the London market, and the number of hop gardens around Canterbury. The changes coincided with increased competition in the London malt trade, which saw a rapid drop in shipments from Kent ports. Later, Arthur Young in his *The Farmers Tour Through the East of England* (1771) commented on barley growing in Kent, which remained important in crop rotations around St Mary Cray, at Dartford and Northfleet, and particularly between St Nicholas in Thanet and Margate, where yields could be as high as 7 or 8 quarters per acre. But Young also commented on the importance of hops in East Kent, a view supported by Ireland in 1828 who stated hop production was by then replacing fruit production – especially in the vicinity of Maidstone, Faversham and Canterbury, 'where hops constitute the leading product of the country.' By the mid-nineteenth century there was a shift towards livestock and a move away from barley towards oats. By 1911, it was reported that barley did not figure extensively in rotations except on the chalk and light soils of east Kent, where the Isle of Thanet produced grain of malting quality, usually the Chevallier varieties, which by the early twentieth century was only sold locally in Kent. Breweries with maltings were, by necessity, buying their grain supplies from out of county.

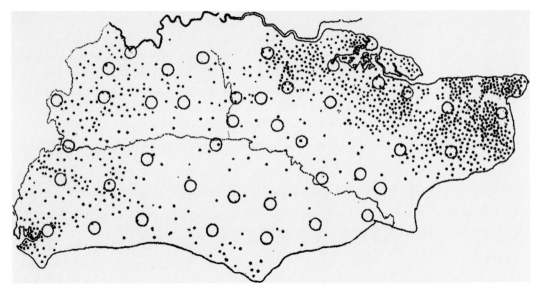

Distribution of barley growing in Kent in 1911. Each dot represents 10 acres. (Hall and Russell, 1911)

In the seventeenth century Kent had produced enough barley and malt to supply the local brewers and a surplus that was shipped from Kent's ports to the London market in particular. C. W. Chalklin estimated that Kent was contributing roughly half of London's imports of malt in the early seventeenth century, in 1615 supplying 27,940 quarters from a total of 36,990 quarters (1 quarter = 8 bushells = 448 lbs barley = 336 lbs malt) and in 1638, 19,090 quarters of a total 39,130 quarters. It was rational for malting to occur near where barley was grown as barley lost weight during the malting process, making malt more economical to transport. Quantities of grain were also shipped for malting elsewhere. Margate was one of the chief exporting harbours in east Kent, a town described by Evelyn in the late seventeenth century as 'much consisted of brewers of a certain heady ale, and they deal much in malt.' (Evelyn, *Diary*, ii.) Malt was shipped in increasing quantities from Sandwich in the seventeenth century, largely to London, sending 27,368 qtrs in 1684. Dover and Faversham shipped lesser quantities.

However, by the early eighteenth century there was a rapid decline in malt shipments to London, although barley continued to be shipped in lesser quantities, some to the breweries of Maidstone and Chatham, where increasing quantities of 'imported' grains were consumed. Local duties collected at Rochester on incoming cargoes of malt and barley showed annual average imports increased from 1,260 quarters in the 1690s to reach almost 10,000 quarters in the 1760s, mostly from Thanet. Ireland was still able to note in the 1820s an immense quantity of grain being shipped from Margate to London, and also from Ramsgate.

London brewers increasingly drew their malt supplies from other areas. Malt was carried from Baldock and Ware, firstly by road and later by barge on the Lea Navigation. It was also being brought down the Thames from Newbury in Defoe's time and, after around 1720, by barge on the Kennet Navigation. A coastal trade developed in the late eighteenth century from malthouses at Colchester, Harwich, Ipswich, Kings Lynn, Norwich and Great Yarmouth.

In the nineteenth century the development of the Great Eastern and Great Northern railways opened inland supplies from Cottishall, Long Melford, Gainsborough, Lincoln, Grantham and Newark. Scattered small maltings inland in Kent were left at a disadvantage, becoming increasingly dependent on Kent brewers – many of whom preferred to make their own malt from local or shipped-in supplies of barley to gain greater control over quality. Many brewers, however, still sourced most of their malt supplies from local independent maltsters. An example was Bests Brewery at Chatham, who in 1844 bought from the following: James Atkins, Rainham; John Anderson, Grange, Gillingham; Thomas Tippin, Rochester; Woodham & Co., Chatham; John Stunt, Twydall, Gillingham; John Fulkes, Frindsbury and William Hook, Gillingham. But they also bought from Howell & Co. of Lower Fore Street, Lambeth and Randell & Co. of Fulham.

That Kent was no longer self-sufficient in either barley or malt by the beginning of the nineteenth century can be seen by reference to brewery purchases. The malthouse purchase book for 1782–1802 at Cobb's Brewery, Margate, indicates that the brewery was buying barley for cash from thirty-six local farmers in small quantities, typically 10 quarters. However, they sourced some of their needs for barley and malt from outside Kent from the end of the eighteenth century. They used agents including R. S. Covell of London (1780s), Latham Osborn Snr of London, and later his son, Latham Osborn Jnr of Margate, who used a 'corn hoy' to ship malt and barley from London (1790–1820s) in some of their transactions. In the 1820s, Cobbs bought from John Cowell at the Corn Exchange, Mark Lane, London, who also traded as J. Cowell & Sons, Ware.

Cobbs' malt book for 1782 to 1844 records trades with George Hankin & Son, Ware, who supplied mostly brown malt from at least 1782 to 1806. Cobbs' *Malt from London, via Mr Osborn's Hoy* book from 1808 lists a number of suppliers of pale, amber, brown and porter malt, apart from Osborn's storehouse, including: Hill & Co.; Ruding; Stonard; Mahon & Co.; Greenside & Co.; Mrs Kemp; Nixon, Swinford, and Marks, and Charrington. In the 1820s Cobbs had dealings with J. Cowell & Sons, Ware, Oswald Howell, Lower Fore Street, Lambeth, John Taylor of Bishop Stortford and later with Randall Plunkett of 48 Mark Lane, London. In times of shortage Cobbs bought in locally, including from George Ash of Canterbury who supplied 200 qtrs of malt at 72s in 1831, and a further sale of 100 qtrs at 70s.

Cobbs also sold malt in earlier years when they had a surplus from their own malthouse. The *Retail Malt Book* for 1782 shows malt sold locally in small parcels from two bushels upward at 4s 3d to 6s per bushel. Larger quantities sold in 1797 included: 485 quarters at 42s delivered to Mr Jeken, Dover, and 175 quarters to the Victualling Office, Dover, with 397 quarters in 1798, and 572 quarters in 1799. However, as considerable quantities of malt were being bought in from the beginning of the 1800s, it seems unlikely that Cobbs continued to supply malt to other brewers. Latham Osborn was selling to other brewers apart from Cobbs, but no information survives apart from that in December 1804, he had sold malt to Sankey, Beer Cart Lane, Canterbury. In the same year Osborn was buying in barley from Essex and from the London market. Latham Osborn evidently had a storehouse at Margate from which he could distribute both malt and barley, but no information is available.

The only other brewery about which there appears to be any information is Shepherd Neame at Faversham where, according to the brewery's archivist Mr Owen, the Shepherd's

involvement with malting varied with the costs of production. In the early nineteenth century their malthouse was leased out and their malt requirements bought in, mostly from Byles & Co. of Ipswich and with a little from Ham Tite at Faversham. Conversely, by 1820 they were producing nearly a quarter of that requirement in their own malthouse. In the 1840s they bought from J. Garrard of Colchester and R. S. Watling of Ipswich, but by the 1860s were self-sufficient in malt from their own malthouses.

Apart from competition from other barley growing areas, the Kent malting industry was hit by other factors. Later in the nineteenth century, malt was imported from overseas including from Smyrna, Moravia, Spain and the USA. In 1899, Shepherd Neame purchased 240 quarters from Spain and, in 1900, pale malt from California, while after 1901 both Shepherd Neame and Rigden's purchased some of their barley supplies from California.

2

The Malting Process

The floor malting process (in which barley was allowed to germinate on a growing floor before the growth was terminated by heating in a kiln) was used, little changed, in Kent from the Roman era until the late twentieth century. During this process the starch content of the barley, roughly 65 per cent, was converted to sugars that could be fermented into ale/beer. As the industry grew in importance with the expansion of commercial brewing, attempts were made to regulate the manufacture of malt from as early as 1325. Measures included the Act of 1548 for 'The True Making of Malt', which laid down that the flooring of malt should take three weeks, except June, July and August when the process could take seventeen days. The regulation of malting practice was to persist until the abolition of the malt excise in 1880, which had made innovation in the industry virtually impossible. The processes described in brewing literature remain virtually unchanged from the sixteenth century, through writers such as William Harrison (*Description of England*, 1577), William Ellis (*London and Country Brewer*, published by J. & J. Fox, 1736), Alexander Morrice, (*A Treatise on Brewing*, 1802), W. Brande (*Town and Country Brewing Book, c.* 1830), to William Bradford, (*Notes on Maltings and Brewing, 1888*). Harrison stated:

> Our malt is made of the best barley all the yeare long in some great townes; but in the gentlemens' and yeomens' houses, who commonly make sufficient for their own expenses only, the winter half is thought most meet for that commodity.

Whether produced domestically or commercially, the process was the same.

In the commercial production of malt, selected barley was taken to storage at the malt house, usually located on an upper floor. Here, the barley was screened to remove dust and foreign seed. Contamination with weed seeds could be a problem for brewers, and William Ellis pointed out that the seed of 'Mellilet, a most stinking Weed that grows among some Barley' (most likely Melilotus, a kind of sweet clover that has a smell and whose seed might give a bitter taste) could not be easily removed. A screen, sieve, or ' throwing' removed most seed, but the problem of foreign seeds, stones and dust was not removed until Robert Boby of Bury St Edmunds, Suffolk, invented the corn dressing machine that had a self-cleansing screen in 1855. This was improved in 1860 by the attachment of a blower. By the late

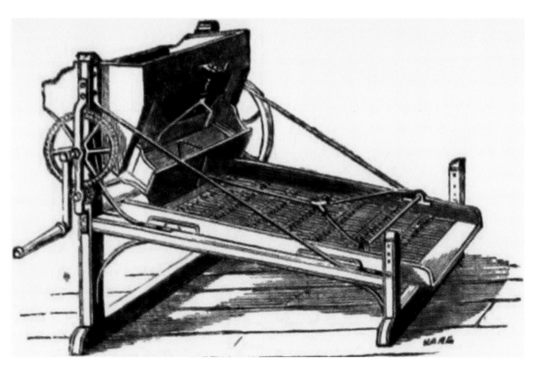

Boby's corn dressing machine, *c.* 1855.

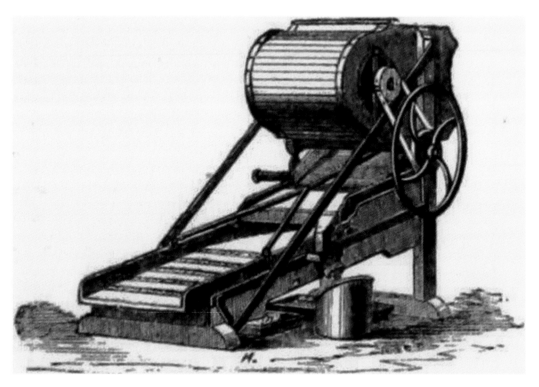

Boby's corn dressing machine with blower, *c.* 1860.

nineteenth century the firm of Robert Boby & Sons had become the leading manufacturer of screening machines.

The next stage was steeping when grain from the store barley was shot down a shoot into a 'steep' (cistern), which was a trough or tank in which the barley could be soaked in water. Early steeps were rectangular, usually constructed from stone or brick, rendered for waterproofing. In 1736 Ellis described the steep as 'a leaden or tyled Cistern that holds five, ten or more Quarters'. The dimensions of the steep were laid down to facilitate Malt Tax calculations in 1697 with a set of regulations which included such matters as: the notification of intention to steep barley, 24 hours in the countryside and 12 hours in town; the hours when barley could be put into the steep, 8 a.m. to 2 p.m., or taken out, 7 a.m. to 4 p.m. Under these regulations the steep had to be flat-bottomed, not more than 40 inches deep, with headroom of 4 feet above with a depth of 2 feet of grain at the bottom. Water was then introduced, usually drawn from a well, and, according to Ellis, to 4 to 6 inches above the barley. The grain swelled to 1.3 to 1.4 times its original size as water was taken up to give a moisture content of 45 per cent. Water in the steep was changed two to four times to keep the grain sweet with the soaking, lasting a legal minimum of 40 hours while the Malt Tax was in force. The temperature of the steep was usually dependent on the temperature of the well water, normally 10 to 15 degrees. According to Ellis, a test to see if the correct level of saturation had been reached was to take a grain between the fingers and crush it gently, and if the husk opened a little from the body it was ready to be drained.

Next, the water was drained and grain left for 6 to 10 hours, after which the steeped grain was thrown by hand into a square wooden frame, a 'couch', which according to the regulations had to be adjacent to the steep. This was used to measure the expansion of grain for assessing tax. The grain had to lay for 26 hours heaped to a depth of 2 feet 6 inches, a process that generated heat to initiate germination. Couching was not universally practised after 1880. After the repeal of the Malt Tax, cast-iron steeps could be used with hopper bottoms or hatches in the bottom that could be placed on an upper floor and which would allow emptying directly onto the floor below, thereby saving a good deal of manual labour – an innovation which was employed at Rigden's, Faversham.

The next stage was sprouting on the growing floor when germinating grain was spread 4 inches deep across the growing floor in what was known as a 'piece'. The thickness of the layer controlled the temperature, and therefore the rate of growth. Care also needed to be taken to prevent a blade developing on the grain, which would deplete the starch content. Thinner layers gave greater heat loss and slowed growth, and vice versa. The ideal floor temperature was 14½–16½ degrees Celsius (58–62 Fahrenheit). Temperature on the growing floor could be controlled by the use of window shutters. There was also a need to prevent drying out, which would terminate germination, and the piece might be watered from watering cans, although, according to the tax regulations, this could not be done for twelve days. The grain was turned four or five times per day with a wooden shovel, or ploughed with wooden pronged implements, to equalise temperature and to prevent the roots from matting. Care needed to be taken not to damage the grain, so labourers worked with bare feet or wore soft leather shoes to prevent damaged grain becoming mouldy and spreading mould and fungal disease throughout the floor. During turning the piece was moved progressively up the floor from the cistern (steep) to the kiln end. The grain had to remain on the growing floor, by law, for at least seven days, but William Bradford observed

in the 1880s that 'in practice this period is much exceeded, the time usually occupied varying from eight to eighteen days'. William Bradford thought that 180–200 square feet of floor space per quarter of wetted grain was required, and that the width of the growing floor should not exceed 50 feet as the temperature in the middle would exceed that on the edge leading to a varying product.

Towards the end of germination the piece was thickened, and the temperature rose to 21 degrees Celsius (70 degrees Fahrenheit). The sprouts, which were now somewhere in the region of ½ inch long, withered, meaning with the loss of moisture that less time was needed in the kiln. Fluctuations in temperature meant that the maltster had to exercise skill in judging the rate of germination, which he tested by rubbing and chewing the grain. Slower germination was practiced more by brewer maltsters, according to William Bradford, as this way more starch was converted, whereas maltsters selling by measure liked quick germination, which bulked up the grain to measure well.

The next operation was kilning. It is possible that in the domestic manufacture of malt the germination of the grain took place on a suitable paved floor within the house, and growth was terminated by heating in domestic ovens. In malthouses early kilns were basic, consisting of a fire basket on the lower floor, about 12 feet below a ceiling of slatted wood similar to that of an oast. Until the eighteenth century a horsehair mat was laid over the slats to form the drying floor, and green malt barrowed or shovelled on. Horsehair mats were, according to Ellis (1736), already being replaced to some extent by perforated tiles and perforated iron plates, and later by woven brass and iron wire supported on metal joists, changes which allowed the higher temperatures required for amber and brown malts. Using the newer materials also reduced fuel consumption as they conducted heat more effectively. An iron plate was suspended beneath the drying floor as a disperser, which distributed the heat more evenly throughout the kiln and which also prevented dried shoots from falling into the fire and setting the building alight. Open fire baskets were replaced by furnaces, the hot air being taken via a shaft or a series of tubes to be dispersed under the drying floor. The hot air passed through the green malt on the drying floor and rose to a central aperture, often fitted with a rotating cowl to prevent down draught, a system which worked better, in the view of many, than square louvred cowls, although William Bradford patented an improved louvered cowl system used at some maltings in Kent, including by Isherwood & Foster at Maidstone.

In Harrison's time the fuel used was 'in some places … wood alone, or strawe alone, in other with wood and strawe together; but of all, the strawe dried is the most excellent'. Wood-dried malt presented some problems, with smoke imparting unwanted flavour. The result was the introduction of coke fuel in the seventeenth century, described by Ellis as 'the right sort being large Pit-coal chark'd or burnt in some measure to a cinder, till all the Sulphur is consumed and evaporated away', which left no offensive tang.

The type of malt required was determined by the duration and intensity of kilning. Malts normally had 1–3 per cent final moisture content. Kilning at a low temperature meant the maximum survival of enzymes and the least development of aroma and colour, with the characteristics changing with higher temperatures. Traditional kilning, which could be affected by the weather, might take up to five days. The initial kilning was at 135–140 degrees Fahrenheit, and when 'hand-dry' the malt was cured up to 176 degrees Fahrenheit (80 degrees Celsius) on the third day for pale malts, and on day four to 203–221 degrees

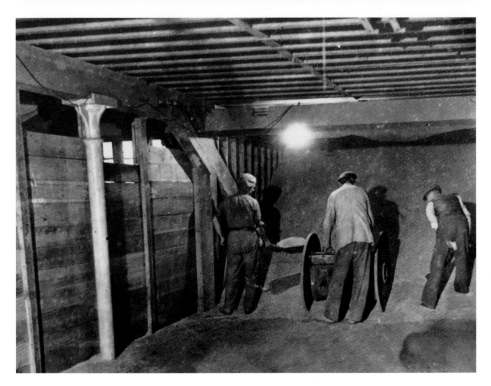

Moving grain from the store to the steep using a traditional barrow. (Whitbread plc)

Working the growing floor in No. 3 malting, Lenham. (Barnard, *Noted Breweries*, 1890)

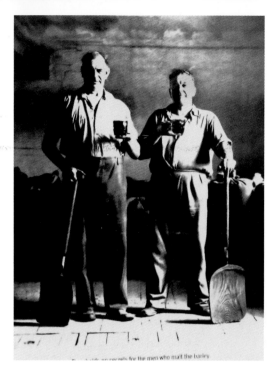

Left: Malt workers with traditional wooden malt shovels. (Whitbread plc)

Below: Malt plough and traditional malt barrow.

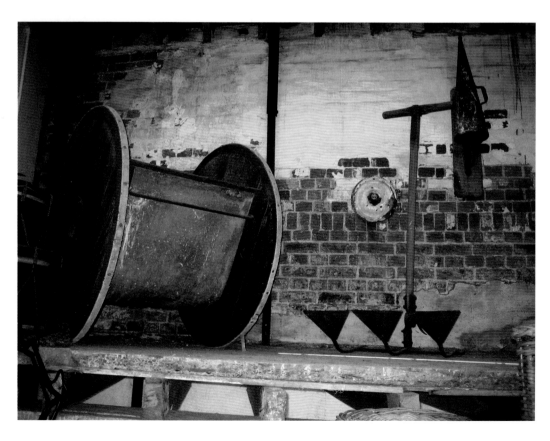

Fahrenheit (95–105 degrees Celsius) for dark malts. Black malt (which made the brewing of porter possible in the early nineteenth century) was usually cylinder roasted elsewhere, normally at the brewery after the invention of the drum roaster in 1817 by Daniel Wheeler. This was heated to 420–450 degrees Fahrenheit, leaving no enzymes so that black malt had to be mixed with pale ale malt to initiate fermentation.

In the kiln, the green malt was spread evenly across the drying floor up to 6 inches deep, where it needed to be turned and raked level by hand using shovels and long-handled pronged forks, not a popular job because of the heat, but essential for the consistent colouring and drying of the batch. A 14–16 feet square kiln would dry 2 quarters of malt.

Kilns were usually placed away from trees that might cause a down draught, and the door was often sited to face the prevailing wind to force a draught. To control the air flow there was often a damper in the chimney. The kiln roof, the interior of which was plastered lathes, was often double thickness for insulation and fire proofing.

Wood, straw and charcoal continued to be used as fuel into the nineteenth century, coal and coke being relatively expensive and less easily accessible than wood, which was untaxed and still fairly locally abundant. Transportation made coal expensive away from the ports, with the result that coal-fired malt was too expensive for many small-scale brewers. Coke became more accessible with the introduction of gas works. Anthracite was also used as fuel, but fear of arsenic poisoning led to the use of chalk blocks in heat channels to try to trap it and to trap gaseous sulphur oxides that could impart unpleasant flavours. Latterly, coke became the fuel of choice.

From the kiln the malt went through a further screening to separate the withered tails, and then into a malt store to rest for up to a month before being bagged up to go to the

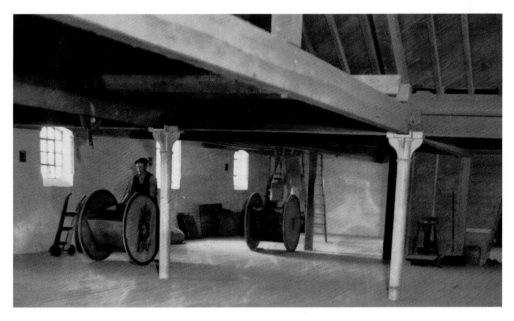

Traditional barrows in use on the floor above the malt bins at St Stephen's malthouse, Canterbury. Malt was collected from the malt screen to be dropped through hatches in the floor into the bins below. (Whitbread plc)

brewer, or, by the late nineteenth century, be transferred by conveyor from malthouse to adjacent brewery, as at Rigden's Brewery, Faversham.

Floor malting was a labour-intensive process with manpower required to raise the barley to the store, often in the loft; to feed grain into the duster; to empty the steep by hand in the earlier malthouses; to spread the grain on the growing floor and to turn and plough the sprouting grain; to load the green malt into the kiln hoisted in baskets on manual hoists or wheeled in barrows; turning the malt in the kiln and shovelling to the malt bins. It was not until the end of the nineteenth century that elevators and screw conveyors came into use at malthouses such as Rigden's, Faversham, and St Stephen's, Canterbury. There was otherwise little by way of technical innovation before the twentieth century, when a number of improvements were made to malthouses that did not radically alter the building. Mechanical turners were introduced, replacing turning by hand, particularly on the drying floor, the least pleasant task in a malthouse.

To maintain a constant temperature over the growing floors, an automatic thermostatically controlled air conditioning plant was installed at St Stephen's and Nettlestead, which could blow air cooled by compressed ammonia through ducts fitted below the ceiling. The kiln or furnace might be replaced by a more modern variety. This happened at Nettlestead in 1941, when the four kilns of one range were replaced by two larger versions with more efficient furnaces.

Mechanical turners in the kiln at St Stephen's, Canterbury. (Whitbread plc)

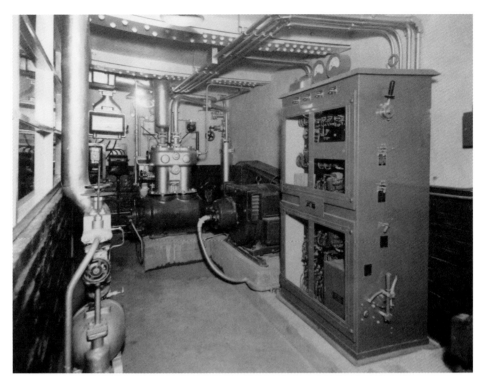

Compressor and thermostatic control for air conditioning at Nettlestead malthouse. (Whitbread plc)

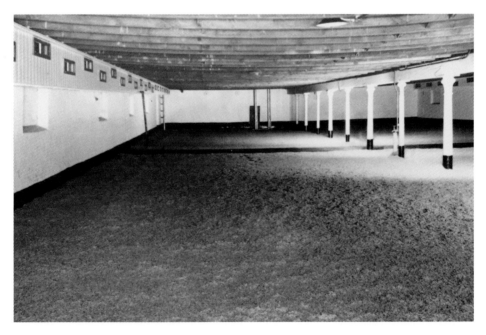

A recently ploughed 'piece' on the floor at Nettlestead with air ducting (upper left) and a tap for watering. (Whitbread plc)

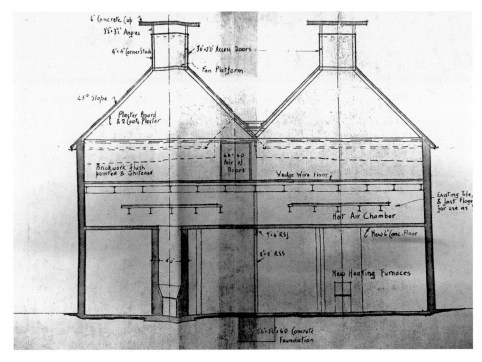

Plan for replacement kilns at Nettlestead, 1941. (Whitbread plc)

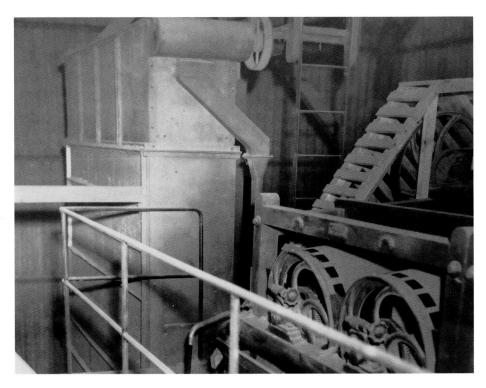

Barley drier, St Stephen's malthouse. (Whitbread plc)

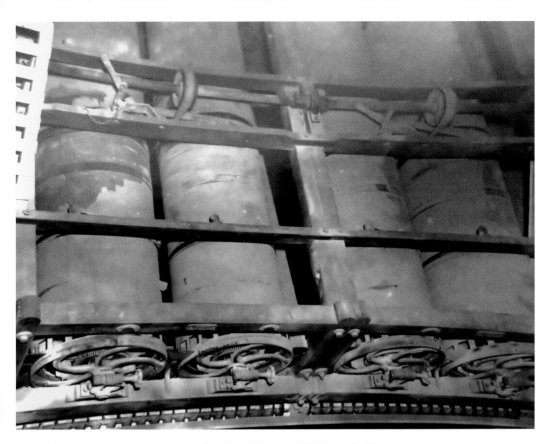

Rotary corn separators, St Stephen's malthouse. (Whitbread plc)

Other modern plant included barley driers (a method previously employed at Nettlestead malthouse had been employing a chamber at loft level above the drying floor in the kiln) and improved rotary corn separators.

The one method of malting that was never adopted in Kent was pneumatic malting, where the barley is sprouted in revolving drums in an artificial atmosphere. This would have necessitated considerable investment, which was better made in barley producing counties such as Norfolk.

3

Building Design

Function determined the design of malthouses. In Kent the traditional malthouse buildings tended to be rectangular two-storey constructions with a kiln to one end, and, to the other, loading doors and a lucam on the first floor and the steep on the ground floor. Some malthouses had the kiln tacked onto the side at the opposite end to the steep, while other early malthouses give the appearance of barns with a kiln inserted internally, as at Bexon and Brabourne. Typically, these could handle up to 15 quarters of barley (1 quarter of steeped barley required 20 cubic feet of floor space) with the sprouting of the barley only on the lower floor. The growing floor was paved, usually with brick or tile, concrete floors

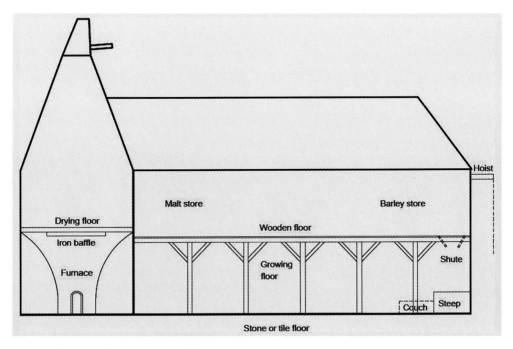

Layout of a typical two-storey malthouse.

being a development of the second half of the nineteenth century. The buildings typically had small shuttered windows and low ceilings, 6 feet 6 inches, to control temperature across the floor. The upper storey, usually with a wooden floor, was used for the storage and screening of barley and for the screening and storage of malt.

As scale of production of beer increased in the nineteenth century, the shape of the malthouse changed in response. This was achieved after 1850, firstly by increasing the dimensions of the two-storey building, by growing on two floors, adding extra kilns, and

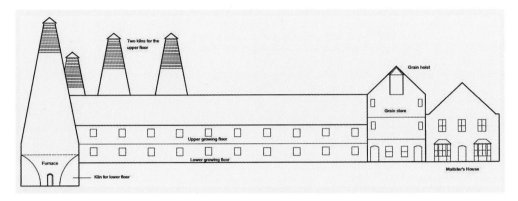

Layout of Preston malthouse, Faversham, as an extended two-storey malthouse.

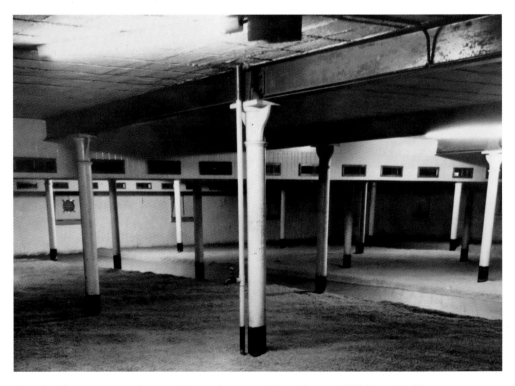

Growing floor supported on cast-iron columns and iron beams. (Whitbread plc)

by adding a grain store at one end and a malt store beyond the kiln at the other end. This was facilitated by the introduction and use of load bearing cast iron columns which would carry the weight of extra growing floors. This approach can be seen at Preston Maltings, Faversham.

A later response, c. 1880 onwards, was to add to the number of floors to increase the growing area as at Close Brewery, Hadlow, or Russell's, Gravesend. At these later malthouses the practice of sinking the lower floor below ground level to form a semi-basement was introduced to reduce the temperature on the floor and extend the malting season into the summer. Grain storage was provided in the loft.

The ultimate design was that similar to St Stephen's, Canterbury, built in 1898 (which is designated a hybrid multi-storey malt house in the Amber Patrick typology) with several growing floors, multiple kilns, grain storage in the upper roof levels and malt storage beyond the kilns.

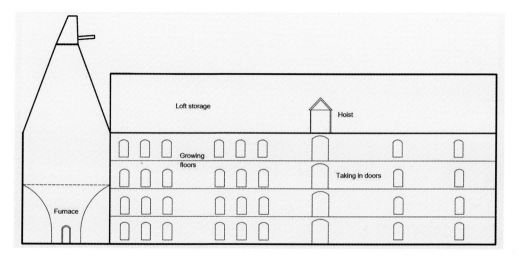

Layout of No. 2 Malthouse, Hadlow, as a multi-storey malting.

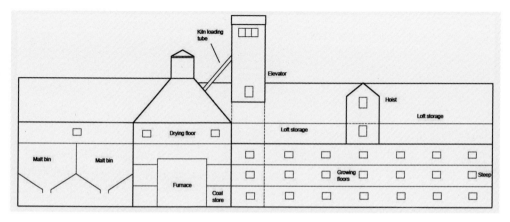

Layout of St Stephen's malthouse, Canterbury, as a Ware Hybrid multi-storey malting.

Kilns followed the pattern found in hop oasts. Square kilns of up to 20 feet square were employed into the early years of the nineteenth century. Following the trend in oasts, malthouses switched to round kilns sometime around 1825 as these were thought to better conduct heat. However, the design reverted to rectangular kilns later in the nineteenth century. Early kilns could be of timber construction lined with laths plastered for fire proofing, with a tiled roof. However, in the nineteenth century, brick and slate were universally employed.

4

Why Did Malthouses Disappear?

The total number of malthouses to have worked in Kent is unknown but probably ran into hundreds; most have disappeared leaving little or no trace. The industry lost its importance as good grade malt, efficiently produced by the pneumatic process, became widely available and as changes in the structure of the brewing industry saw brewing concentrated at plant outside Kent.

Some malthouses were lost accidentally, for instance being destroyed by fire such as a malthouse at Sandhurst Green (converted into almhouses in 1656/7), which was, according to Hasted, burnt down, or at Loose where Thomas Kemp occupied a malthouse that a newspaper reported was destroyed in a fire on 25 January 1875. East Farleigh malthouse was demolished in 1997 after being damaged in a flood. However, most, when redundant, were either demolished or converted to other uses. It is possible to try to explain their demise in terms of the wider environment of the brewing industry.

Loss of the London market

In the late sixteenth and seventeenth centuries a large number of typically 7- to 10- quarter maltings in the Thanet, Dover, Sandwich and Faversham areas served the London malt trade. As already mentioned, although barley continued to be shipped, in the early eighteenth century there was a rapid decline of malt shipments in the face of fierce competition from other areas of the country. Many small malthouses must have become redundant, been converted to other uses or demolished.

Disappearance of farm or estate brewing

There are references in documentary sources, mostly from the seventeenth century, to malthouses at farms and estate houses that provided malt for household brewing. With the increased availability of commercially brewed beer, estate or domestic production had all but disappeared in the early nineteenth century and any malthouse became redundant.

Disappearance of publican brewers

Until the early nineteenth century there was a large number of domestic brewers selling beer from their homes and larger-scale publican brewers, some of whom were also maltsters. Examples found at Faversham include the Hole in the Wall public house, formerly the Albion Wine Vaults, in Preston Street from at least 1619, which had its own malthouse and hop gardens. Another in the mid-eighteenth century that had 'a still house, a malthouse and barns' was the Fountain Inn in West Street. There was a publican brewer at the White Horse public house at Boughton under Blean (TR 0556 5947), which had an adjacent malthouse dating from the 1750s that was converted to a hop oast in 1874, but demolished in the 1950s. A late example of a Publican brewer is William Harrison, Balmoral and Family Hotel, Broadstairs, brewer, maltster and wine merchant at Albion Street, listed in Kelly 1855. Reference to directories shows that publican brewers disappeared soon after the mid-nineteenth century, faced with competitively priced and reliable beers from the commercial brewers. Their redundant malthouses disappeared.

Brewers adding malthouses to their plant

Brewers increasingly built malthouses for in-house production so that they could have a reliable supply of malt at a uniform quality, while eliminating the middle man. Small maltsters were not able to regularly supply the larger quantities of quality malt demanded by commercial brewers, or meet new demands on moisture content and colour which were difficult for small producers, whereas by the end of the nineteenth century the big breweries might be equipped with laboratories.

A sample of directories illustrates the trend towards brewer maltsters.

		Independent	Brewer Malts
Bagshaw	1847	34	15
Kelly	1859	54	19
Kelly	1874	24	26
Kelly	1899	12	21
Kelly	1930	3	5

The brewing environment

There were a number of commercial pressures weighing on the brewing industry which were to have knock-on effects on malting. In the second half of the nineteenth century brewing was very competitive, with profits static or declining. Beer consumption per head reached a peak in 1878, only to fall rapidly, and continue falling, so that in the 1930s consumption of beer per head had declined to half that of pre-1914.

Nationally, the peak production of malt was at about 45 million bushels in 1873/4. The market for malt was not helped by restrictions on the sole use of malt in brewing being lifted in 1847, with increasing amounts of sugar being used in the fermentation process reducing demand.

Competition arose from the increasing availability of safer water supplies and increased tea and coffee drinking. For instance, Gravesend waterworks dated from 1846; Castle Hill, Dover, from 1854; Luton, Chatham and Maidstone with a pumping station at East Farleigh from 1860, and Margate Corporation waterworks at Wingham from 1903. This was accompanied by the growth of the mineral water and soft drinks industry, with sixty-four manufacturers listed in 1882, with some firms, such as Dove Phillips, Pett of Strood and D. T. Lyle of Frindsbury, eventually taking over redundant breweries. They, and others like R. White of Bexley, were able to distribute bottled drinks widely by the early twentieth century. There was also competition from out-of-county brewers with local depots including Ind, Coope & Co. and Truman Hanbury & Co., as well as from bottled beer and stout from firms such as Guinness. Add to this the Temperance Movement and restrictive licensing brought in by Gladstone and the need to restructure the brewing industry, which still consisted in Kent of 100 breweries in 1880, becomes apparent. Small, particularly inland, breweries were vulnerable as transport improvements removed the protection previously afforded by poor roads limiting the radius for the carriage of cask beer to about 7 miles.

The disappearance of numerous maltsters that were recorded in early directories and the tithe assessments might be explained by brewers constructing their own larger-scale malthouses, but also by the disappearance of small brewers. Examples of brewers who disappear in the mid-nineteenth century are George Pope of Gillingham and Thomas Clarke of Strood, with maltsters in their areas disappearing around the same time. Newspaper reports record small

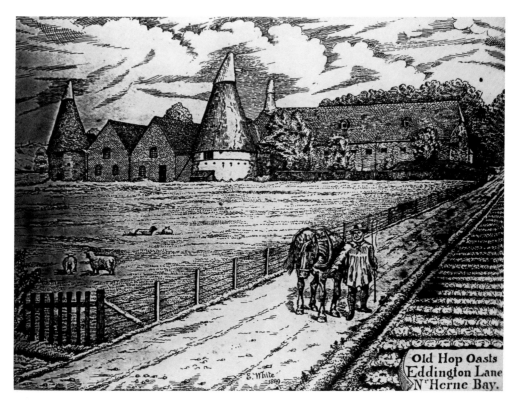

Eddington Lane malthouse.

breweries, often with malthouses, which were closed and auctioned, never to reopen. In the *Kentish Gazette* for September 1860, examples include the Drellingore Brewery, Alkham, with stock in trade and premises including a 'Freehold Dwelling House, with malthouse, stable and outbuildings'. Jeken's Brewery, located at Custom House Quay, Dover (TR 3167 4055), ceased brewing and buildings were demolished by 1864. After the death of G. S. Page, the brewery in Limekiln Street, Dover (TR 3163 4075), with 'a Capital 16 Quarter Malting with good Barley and Malt stores' was auctioned on 6 March 1874, but not reopened. The Star Brewery and maltings at Wye, being within transport distance of the Ashford breweries, were demolished before the survey for the second edition OS. The Northend Brewery, Beach Street, Deal (TR 3775 5340), closed in 1877 at the end of the lease when it appears that the brewery was no longer a viable prospect. Among others, E. G. Wastell & Co., Thanet Brewery, Queen Street, Ramsgate, became bankrupt in 1890. The Burton Brewery, William Street, Herne Bay, brewed from 1874 but ceased production about 1905, with likely casualties of the closure including a malthouse situated just west of Broomfield Pond, Herne (TR 1985 6674), owned and occupied by J. Collard; a malthouse owned by E. Collard on the north side of Eddington Lane (TR 1749 6723), later converted to a hop oast, and a third malthouse located in Cobbler's Bridge Road (then Station Road), Herne Bay (TR 16786747).

Amalgamation of local brewing firms

The reaction of some of the larger breweries to the pressures, particularly to restrictive licencing, was to try and secure their market by expanding their tied estate of public houses. A. F. Style of Maidstone, for example, bought free houses when they came on the market. However, the preferred method was to buy brewing businesses in order to acquire the tied estate, and then close excess brewing capacity, thus restructuring brewing locally and reducing the market for independent maltsters. This allowed economies of scale by supply from a central brewery and distribution by rail or the improving roads. The effect was to reduce the number of breweries in Kent to fifty-two by 1913, with virtually no market for independent maltsters.

This restructuring was a two-part process where the earlier mergers were between stronger local firms and their weaker rivals, followed by the intervention of regional and national brewers. Encouraging takeovers was the situation breweries and malthouses occupied in prominent positions in towns and villages, which in the late nineteenth century had become valuable redevelopment sites. In Ashford, no malthouses remain although a number survived into the twentieth century, some having been located in High Street.

Canterbury is another urban centre where there was a proliferation of breweries and maltings which offered opportunities to acquire both tied estate and potential development sites. The Original Brewery, Broad Street (TR 1529 5779), built by William and Alfred James Beer in 1848, was acquired by B. C. Bushell & Co. Ltd of Westerham in 1894, then closed in 1899 and the site (now the magistrates' courts), including the maltings, cleared. George Beer's 1848-built Star Brewery (TR 1524 5778), also in Broad Street, merged with Rigden & Co. of Faversham in 1922 to form George Beer & Rigden Ltd. Brewing was concentrated at Faversham, the Broad Street site being closed and buildings including the maltings demolished in 1936 for redevelopment. The brewery and malthouse in Beer Cart

Lane, which was associated with the Rigden family, closed around the time of the 1922 George Beer and Rigden's merger and the site was redeveloped.

Ash's Dane John Brewery, Watling Street (TR 1480 5749), amalgamated with the East Kent Brewery of Sandwich in 1920 to form Ash's East Kent Brewery Co. Ltd. In 1923, this merger passed into the hands of Jude Hanbury & Co. of Wateringbury, with Jude Hanbury transferring brewing to Canterbury in 1924. However, Canterbury Brewery was to close in 1933 and the site was redeveloped.

In Ivy Lane the Eagle Brewery was sold to B. C. Bushell of the Black Eagle Brewery in Westerham in 1899, its site now occupied by the car park at the junction of Ivy Lane and Chantry Lane. Flint & Co. of St Dunstan's Brewery (whose malthouse survives) bought at auction in July 1904 the Stourmouth Brewery (TR 25586273) to gain control of its eleven public houses. This brewery, which had a 30-quarter malthouse with one pyramidal kiln, closed in 1905 when the plant was sold, and the malthouse and other buildings demolished. Flints were themselves absorbed by Alfred Leney of Dover in 1929 and closed.

Only two small independent maltsters in Canterbury survived into the second half of the nineteenth century, J. Bushell at 20 Guildhall Street and D. Hitching Bushell of Old Dover Road (TR 1517 5741), only to disappear by 1890. At Sturry, up for auction in 1903 was 'a substantially built brick and tile Malt-House easily convertible into cottages'.

As a busy port Dover was able to support a number of breweries with their own maltings, all of which were either to cease trading or were involved in takeovers that resulted in closure and demolition. The dominant concern was the Phoenix Brewery in Dolphin Lane (TR 3210 4142), dating from 1740. From 1868 the brewery was operated by Alfred Leney and his sons Alfred Jnr and Hugh, trading as Leney & Co. until 1926. The Phoenix Brewery operated four substantial malthouses: one abutted on Castle Street (and the east side of Phoenix Passage, later used as an office and cooperage); a second adjoined the east end of the brewery (south of Dolphin Lane and west of St James's Place); a third stood on the site formerly occupied by Poulter's Brewery in Russell Street (Castle Brewery) and the fourth occupied the area between St James's Place and the gasworks yard (No. 3 Malthouse). This latter malthouse was of 50-quarters capacity, brick-built of three storeys with a double kiln one end and a barley store the other. There were two growing floors, concreted, 82 × 45 feet, each having a 25-quarter steep. The kiln was wire floored, consisting of three furnaces that were each enclosed in brick arches with a spark plate/heat dispenser.

Two smaller breweries were acquired by Leney & Co. First was Thomas Huntly's Castle Brewery and malthouse in Castle Street (TR 3213 4154), which became the site of their No. 4 malthouse. The other, originally known as Maxton Brewery, Folkestone Road, Maxton, later as the Diamond Brewery (TR 3032 4082), which had a malthouse on site, was bought in 1912 and closed in 1916. Leney & Co. also acquired the malthouse of the Buckland Brewery, London Road, after Kingsford & Co. was acquired by George Beer of Canterbury in 1887. Leney & Co. was itself absorbed by Fremlins of Maidstone in 1926, brewing ceased in 1927, and although some of the buildings were used for the manufacture of waters and soft drinks until 1950, all buildings, including the malthouses, were progressively demolished before 1965.

In mid-Kent, A. F. Style of the Medway Brewery, Maidstone, followed an aggressive policy of merger or purchase in his drive to acquire tied houses. He had been an aggressive purchaser of free houses in the late nineteenth century, but wanted to eliminate rivals to acquire market share. In 1899 he merged with Edward Winch & Sons, who had leased in

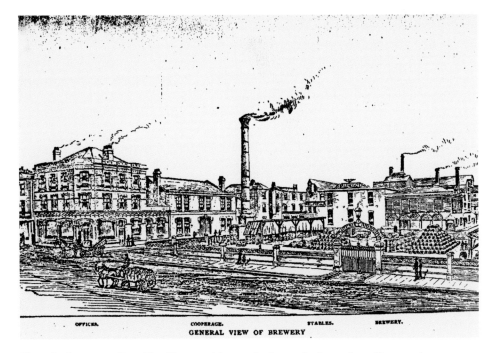

OFFICES.　　　COOPERAGE.　　　STABLES.　　　BREWERY.
GENERAL VIEW OF BREWERY

Phoenix Brewery, 1890. The No. 1 malthouse had stood where the offices and cooperage are indicated. (Barnard, *Noted Breweries*)

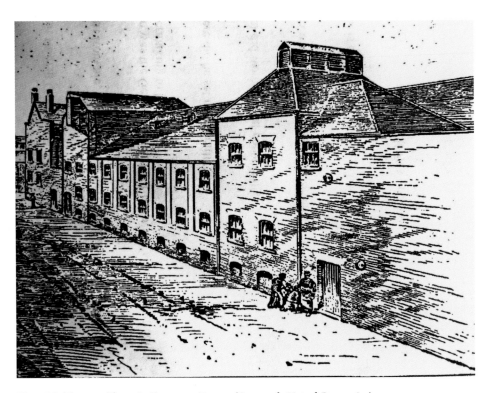

No. 3 Malthouse, Phoenix Brewery, Dover. (Barnard, *Noted Breweries*)

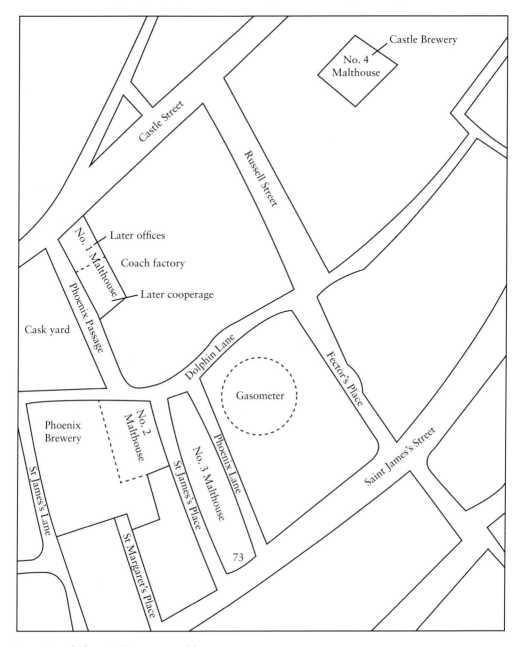

Location of Phoenix Brewery malthouses.

1851 and then bought the former Best Brewery in Chatham High Street in 1894. The brewery and associated malthouses at 313 High Street and on the east side of Clover Street, Chatham (TQ 75556797), were closed, and being in the centre of the town, demolished. Hulkes Brewery in Chatham Intra was bought in 1912 and closed. Woodham's Victoria Street, Rochester Brewery, which had already bought and closed Dampier's Brewery on Frindsbury Hill in 1906, was purchased by Style & Winch in 1918. Woodham's had been associated with two

Free School Lane Malthouse, Rochester. (Medway Archives, Couchman Collection)

malthouses in Rochester, one on Free School Lane (TQ7448 6841), in use until 1929 (although from 1891 by Meux's Brewery Co. Ltd, Horseshoe Brewery, Tottenham Court Road); the second being St Margaret's Malting, St Margaret's Street, Rochester (TQ 7410 6830), a large oblong building with the kiln at the west end, which was in use until the Troy Town Steam Brewery was sold and closed in 1918. Redundant, it was eventually demolished.

In 1905, Style & Winch acquired and closed the Vallance Brewery in Sittingbourne, the site of which was cleared and redeveloped, along with that of redundant maltings on High Street. There followed the purchase of Ashford Brewery in 1912, and then Finns at Lydd in 1921. Edwin Finn had started brewing in 1862 at what was formerly Catherine Green's Sun Brewery, transferring to High Street after acquiring Alfred White's Brewery, where he built a new brewery and maltings in 1885 (TR 0415 2093). Style & Winch closed the site in 1921 and demolished all buildings, including the maltings.

A further major purchase by Style & Winch in 1924 was the Dartford Brewery in Lowfield Street. As the Dartford Brewery Co., this firm had bought out Bartram's Brewery, High Street, Tonbridge (TQ 590 464), in 1902, which was equipped with at least one malthouse, to gain control of the fifty-one tied houses. The brewery was closed and buildings demolished. Dartford Brewery went on to purchase the New Northfleet Brewery, the location of whose maltings is unknown, in 1907, and Smith's Lamberhurst Brewery in 1922, both of which were closed. Style & Winch closed the Dartford site, after which all buildings, including the maltings, were demolished.

Style & Winch, who had concentrated all brewing at the Medway Brewery, St Peter's Street, Maidstone (TQ 7560 5556), closed and sold the sites of its purchases for non-brewing purposes, and used a much-expanded tied estate to maintain its beer sales.

Fremlins Pale Ale Brewery, Earl Street, Maidstone (TQ 7585 5584), had a substantial brewery complex with its own maltings. It also sought to expand its tied estate of public houses. Their first purchase in 1923, the Northgate Brewery, Canterbury (TR 1552 5862), had its own malthouse. The site was closed, but it only brought one public house and two off-licences. A very large acquisition was the 1926 purchase of Alfred Leney & Co. Ltd of the Phoenix Brewery, Dover, which was closed with the loss of the four substantial malthouses. A further 151 houses were gained through the acquisition of Isherwood, Foster & Stacey Ltd of Lower Brewery, Lower Stone Street (TQ 7625 5557), at the foot of St Gabriel's Hill, Maidstone (the site now buried under the Chequers Centre). Their maltings had adopted Wiliam Bradford's patent cowl. Bought by Fremlins Ltd in 1929, the brewery was closed soon after and part of the premises used in the early 1930s by the British Aircraft Company to build gliders and powered gliders. Their final major acquisition was Rigden's at Faversham in 1948, where brewing ceased in 1954.

The remaining Maidstone brewer with about eighty public houses, E. Mason & Co. Ltd, Waterside Brewery, who did not possess their own maltings, was bought by Shepherd Neame Ltd. in 1956, closed and the brewery demolished.

The closure of the Maidstone breweries would have had a knock-on effect on the local independent maltsters. Only two remained in business until the late 1930s, Pine & Sons, St Peter's Street, who worked three ranges of maltings, and Thomas Charlton, High Street, Maidstone. They appear to have supplied Style & Winch.

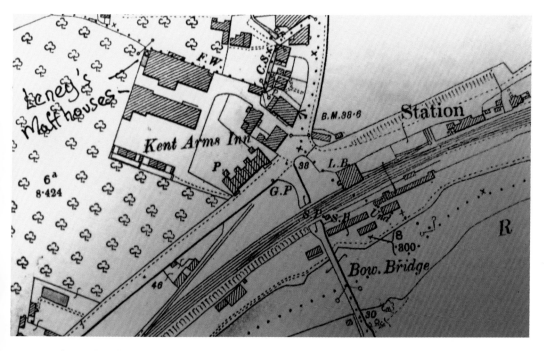

Nettlestead malthouses. (Whitbread plc)

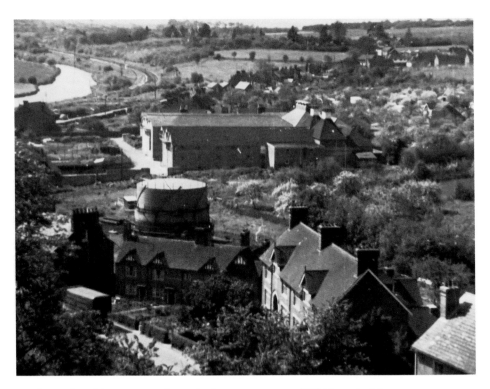

Nettlestead malthouses seen from the brewery *c.* 1947. (Whitbread plc)

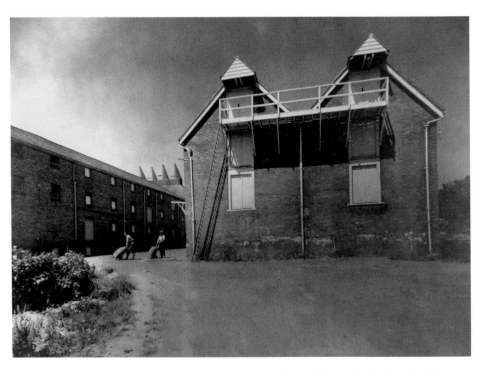

Loading doors and lucams on the eastern range, Nettlestead, 1937. (Whitbread plc)

Another predator was F. Leney & Sons of the Phoenix Brewery, Wateringbury, whose firm was founded by Augustus Leney in 1843. The brewery operated the Nettlestead maltings (TQ 6900 6285) behind the inn variously named the Kent Arms Inn and the Railway Hotel, opposite the level crossing at Wateringbury station. These would have been conveniently situated for the receipt of grain and the dispatch of malt by rail or by barge on the nearby Medway. The maltings consisted of two substantial rectangular buildings lying north-west to south-east with the kilns at the north-west ends. Each was of four storeys with growing floors supported on cast-iron columns on the lower three, and storage on the top floor. The ground floor was submerged to window level. The easterly range had its kilns reconstructed sometime after 1941 when the four kilns, as in the westerly range, were replaced by two large kilns under pyramidal roofs, with wire mesh floors at second-floor level and the furnace at ground level. These modernised malthouses were to remain in use until 1981.

In 1895 the firm purchased the Milton Brewery (TR 904 648) in Brewery Lane, Milton (next Sittingbourne), from Edward Hartridge. The brewery, together with its maltings, was closed, with the probable knock-on effect that a malthouse on London Road (TQ 8897 6407) became redundant, later to be converted into a terrace of four cottages. A further malthouse at Key Street, run from 1891 by Mrs Frances Atkins (who was also at Hollingbourne), was closed. Leney went on to purchase T. Wickham & Co. of Yalding in 1921 and Sharp & Winch, Bakers Cross, Cranbrook, in 1927, both of which were closed.

Russell's Gravesend Brewery, West Street, was also involved in eliminating competition. Local rivals the Wilmington Brewery Co. Ltd, 14 Hythe Street, Dartford, were acquired in 1899 and in 1911, George Wood & Son Ltd, East Street, Gravesend (TQ 6487 7442), where there were also maltings on site, both being closed. Further afield, the Fort Brewery Co. Margate Ltd, Fort Road, Margate (TR 3540 7117), which is listed in directories as having maltings (although these may actually have been at Sandwich), was bought in 1897. The brewing and malting appear to have ceased with the site used for sales from the brewery tap. Also in 1899, Austen's Brewery in Broad Street, Ramsgate (TR 3778 6565), a brewery with maltings, was acquired, with brewing ending in 1919 and demolition following in 1937.

Elsewhere in western Kent, an acquisitive firm was B. C. Bushell, Black Eagle Brewery, High Street, Westerham (TQ 4425 5375), where there had been a malthouse on site since the 1820s, and a brew house from the 1830s. An early purchase was Beer & Co., Original Brewery, Canterbury, in 1894. The Black Eagle then merged with the Swan Brewery, Hosey Hill, Westerham (TQ 449 539), in 1897 becoming Bushell, Watkins & Smith Ltd. The Swan Brewery under the Watkins family had maltings, though the precise location is unknown, but William Watkins is listed in Kelly 1867 as a maltster at Edenbridge, where the location is most likely in the close vicinity of Malt Cottages in Pootings Road, Crockham Hill, Edenbridge. The Swan Brewery was presumably closed, the site not being marked on the third edition OS as a brewery. In 1899 Alfred Smith & Co., Sevenoaks Brewery, High Street, Sevenoaks, was purchased with twenty-five public houses and malthouses described as 'massive and lengthy'. The brewery and buildings were closed and demolished.

In east Kent, the firm of Mackeson & Co. Ltd of Hythe engaged in acquisitions. In 1886, the Tontine Brewery in Mill Bay, off Tontine Street, Folkestone (TR 229 361), was purchased. Mackeson immediately stopped brewing and the malthouse ceased being used. The Sun Brewery, otherwise known as the Littlebourne Brewery, Nargate Street (TR 2099 5743),

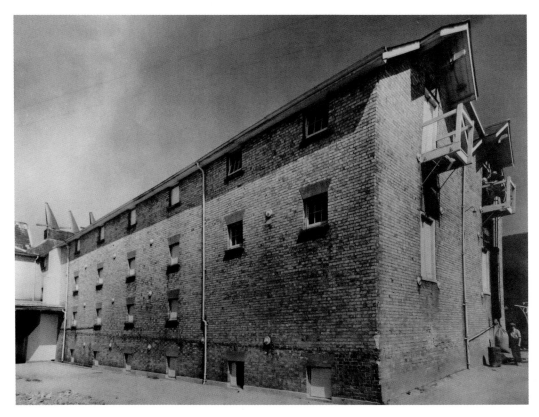

The eastern range, Nettlestead *c.* 1937. (Whitbread plc)

was sold to Mackeson in 1907 and closed, with its brew house and maltings demolished. Mackeson itself was acquired by H. & G. Simmons of Reading in 1920 before being sold on to Jude Hanbury in 1929, to eventually fall under the control of Whitbreads. Brewing ceased in 1968, though the malthouse has survived.

The East Kent Brewery, Strand Street, Sandwich (TR 3323 5821), which operated two malthouses that stood alongside Bell Lane, Sandwich, acquired upon the bankruptcy of R. Baxter & Co. in 1895 the Export Brewery, St Peter's Street, Sandwich (TR 3312 5818), which had a capacity of about 5,000 barrels per annum and included a 13-quarter malting. A further purchase was the Bulwark Hill Brewery, Dover, in 1895, which had become bankrupt in 1890 but which does not appear to have had its own malthouse.

Gardner & Co. Ltd, Ash Brewery, Ash (TR 2925 5839), dated from 1837 when John Bushell converted the parish workhouse. The brewery was bought by William Gardner in 1840. As there was no malthouse on site, Gardner acquired, in 1858, a malthouse at High Street, Littlebourne (TR 2085 5742), from which to transport his requirements. The Littlebourne malthouse was to remain in use until 1962. In 1912, Gardners absorbed Frank Tritton's Staple Brewery, Barnsole (TR 2789 5636), run by the Tritton family from *c.* 1800. Brewing of beer ceased, and all buildings including the maltings were cleared.

Their biggest merger came in 1951 when Gardners joined with Tomson & Wotton Ltd, The Queen Street Brewery, Ramsgate (TR 3805 6482), to form Combined Breweries, with

brewing ceasing at Ash in 1954. The Queen Street Brewery had existed since 1554, with a malthouse from at least 1635. Thomas Tomson acquired the brewery in 1680 and it remained in family control into the nineteenth century. In 1867 T. Wotton was taken into partnership, and the firm traded as Tomson & Wotton until 1952. The original maltings were two long buildings marked on the first to third editions OS at the north-east end of the brewery, but these had been partially demolished by the fourth edition (in 1962, the kiln of one of the originals served as a boiler house for the brewery and still had a cowl on its roof). These had been supplemented in *c.* 1892 and *c.* 1912 by two new malthouses located across the road on Elms Avenue. However, by 1962 one was used for storage, but the brewery could still supply all its own needs and sold malt to one (unspecified) national brewery. In 1959 a Suxe burner with hopper feed was installed instead of an open fire, which was effective in controlling kiln temperature and cost. The result was that malting continued at Queen Street until the closure of the brewery by Whitbread in 1968. The maltings were demolished soon after, to be replaced by a supermarket. Tomson & Wotton had acquired its local rivals, the Cannon Brewery, Cannon Street, Ramsgate, in 1878, which continued in operation until 1920. They also purchased Paramor & Son, Phoenix Brewery, Margate, in 1891, although this latter firm probably had maltings elsewhere.

With the degree of amalgamation going on within the brewing industry, it is no surprise that virtually all the independent maltsters had disappeared by the early years of the twentieth century. Now-redundant malthouses continue to be offered for sale, one example formerly belonging to Bushell & Son being in Minnis Road, Birchington (TR 2968 6935). On 23 July 1913, the malthouse was sold at auction; the prospectus described it as

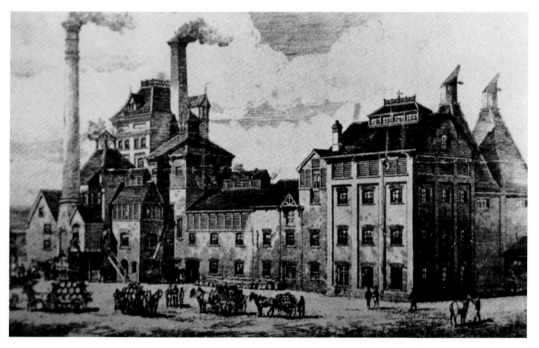

C. N. Kidd & Son Ltd, Dartford, showing the newly rebuilt brewery with the malthouses to the right. (First appeared in the Brewers' Journal, 1890, taken from a copy in Dartford Library)

'the well built freehold property known as the Malt House, Minnis Bay Road, Birchington together with two freehold cottages and building land, total area 1acre, 1 rod 12 perches, occupying an excellent position adjoining the Railway Siding at Birchington Station'. The malthouse was 'well built of brick and slate, fully equipped with soaking trough, growing floor, two kilns and well arranged furnaces, also the artesian well with pump, donkey engine and store tank'. The malthouse, unoccupied at the time of the sale, was never reused for malting. Usually, the fate of redundant malthouses, if the building was suitable, was conversion to housing of some kind or to use as a hop oast. If suitably located, some were used for some commercial purposes, unless it was in urban areas when demolition and redevelopment was the most profitable option.

The second stage of restructuring saw big London brewers make acquisitions in Kent. The tied estate was the target, although some breweries and malthouses were kept in production. Whitbread made the most purchases. Their acquisitions included F. Leney & Sons Ltd, Wateringbury, in 1927, where malting continued until closure in 1981. In 1933 the purchase of Jude Hanbury & Co., Kent Brewery, Wateringbury (TQ 6920 5345), also brought Ash's East Kent Brewery and Mackeson at Hythe into their possession. Fremlins Ltd with 714 public houses was bought by Whitbread in 1967 and the brewery closed in October 1972, by which time malting had ceased. Finally, the Combined Breweries and Cobbs of Margate (demolished with its malthouse in 1971) were acquired in 1968.

Barclay Perkins & Co., later Courage, purchased Style & Winch, Maidstone, in 1929 with 600 tied houses, with brewing continuing until closure in 1971, and, in 1937, C. N. Kidd & Sons Ltd, Hythe Street, Dartford (TQ 5410 7417), where, in 1890, the brewery and maltings had been reconstructed and enlarged. Renamed the Steam Brewery, the brewery was closed and demolished in 1939.

Charrington & Co. acquired the Wellington Brewery, Wellington Street, Gravesend (TQ 2558 6273), with associated maltings from Walker & Son Ltd in 1902. The brewery was damaged by fire in 1928, closed and was demolished, although malting may have continued at Chalk. In 1950 a major purchase was the Walmer Brewery (TR 3680 4990), which under John Matthews was enlarged with four new maltings in 1867. Under Charrington & Co. Ltd, brewing ceasing in 1960, but the firm retained 35 quarters steeping capacity and the ability to manufacture 10,000 quarters of malt annually, with the malt used in house, and also sent in large quantities 'all over the south of England' before closure in 1974 and demolition in 1978. Their last purchase was Kenward & Court, Hadlow, in 1952.

Watney, Combe, Reid & Co. Ltd in 1911 bought John Bligh, Holmesdale Brewery, 117 High Street, Sevenoaks, with twenty-seven tied houses, but brewery and malthouses were demolished. The Black Eagle Brewery, Westerham, was taken over by Taylor Walker in 1948 and continued brewing (and presumably malting) until 1965. Russell's Gravesend Brewery was bought by Truman, Hanbury & Buxton with its 223 tied houses in 1930, with the brewery closed and its plant put up for sale in 1935. Lastly, Budden & Biggs Brewery, High Street, Strood, which had been bought by Allsopps, was closed in 1931.

After the national brewers had closed what remained of their facilities in Kent only one brewer was left in production, Shepherd Neame of Court Street, Faversham (TR 0154 6155). There had been a malthouse at the Shepherd Neame Brewery from at least 1705, and it was used until about 1880. Julius Shepherd built, in about 1795, the Standard Malthouse (TQ 0195 6185) near the junction of Abbey Street and Abbey Road. The building had been

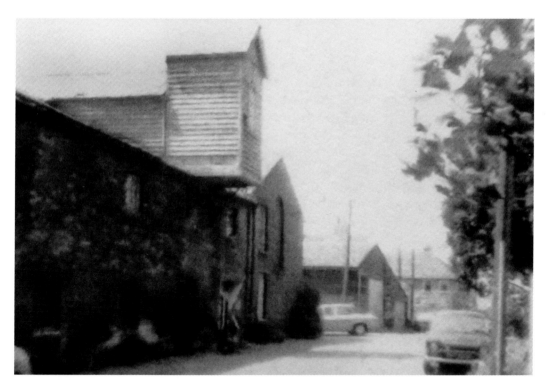

Standard Malthouse seen from the Anchor. (Arthur Percival Collection)

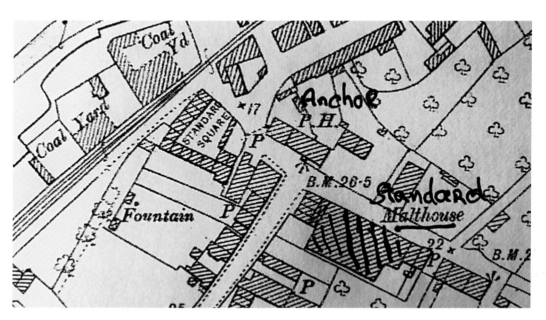

Standard Malthouse marked on second edition OS.

extended to the south in 1859, doubling the growing floor area. In the early 1860s, it was supplied by eighty-six local farmers, each sending on average about 30 quarters of barley. These maltings were used until the 1960s when they were sold, and later demolished in 1978. The closure of the Preston malthouse at the same time brought an end to the direct involvement of the brewery in malt production.

By the twentieth century, floor malting was an obsolete technology, having been replaced by the more efficient and cost effective drum malting. There had been limited investment in new technology in Kent, with any expenditure being purely to enhance the existing floor malting plant. Floor malting was a lengthy, labour-intensive operation whose costs compared unfavourably with industrialised malting, which could enjoy economies of scale. Added to this, drum malting could speed up the germination stage of the process to four or five days, and was more controllable to produce a consistent product. A further factor was the efficiencies resulting from location in prime barley producing counties such as Norfolk. The production of barley in Kent had always depended on its profitability compared with other crops. By the mid-twentieth century, the soils of Thanet were ideal for the production of vegetable crops for the ever growing London food market. Cabbage and cauliflower could be more profitable than barley. The number of floor maltings nationally had declined to four by 2014, and these were largely saved by the emergence of the real ale movement.

In Kent, all that was left of the malting industry was abandoned buildings, many of which in urban areas were demolished to make way for redevelopment. Fortunately, but belatedly, the historical value of the remaining buildings has been accepted, leaving examples which illustrate the full range of building types employed in floor malting.

5

Surviving Malthouses

The earliest surviving malthouses date from the fifteenth century. Over the years, these have been converted into living accommodation and have the appearance of timber-framed dwelling houses. Some may have had internal kilns that have been removed, as have all other internal features which might signify a malthouse.

The Malt House, FORDWICH (TR 1805 5965), is a timber-framed Wealden Hall-style house dated 1418, with a continuous over-sailing jetty across the façade under a steep-hipped tile roof. The weatherboarding is not original. Its dimensions are 13 × 5½ metres, the hall being one bay of 4 metres with a similar-sized solar, passage and a service area. How it originally worked as a malting is uncertain, but as the ground-floor ceiling level is very low it is suggestive of use as a growing floor, and there may well have been an external kiln to the rear.

At HOLLINGBOURNE the Malt House (TQ 8446 5533) is a fifteenth-century timber-framed building with plaster infill under a hipped tiled roof standing on a stone-rubble base. Now converted to accommodation, the location of any kiln is uncertain. Daniel Clifford is named occupier in the tithe assessment and listed as maltster in *Melville's Directory & Gazetteer of Kent*, 1858. Kelly listed maltsters operating in Hollingbourne into the twentieth century, including: T. Farmer (1859); Mark Atkins (also of Boughton Monchelsea) (1867 and 1874); William Henry Atkins (1882); Mrs Frances Atkins, also at Key Street (1891), and Atkins Bros (1899 and 1903).

A sixteenth-century building at LYNSTED named the Malt House (TQ 9490 6190) appears to be a quite high-status yeoman's house dating from *c.* 1567–1599. It is a timber-framed jettied house under a tiled roof. No trace of malting can be ascertained, but outbuildings and an external kiln could well have been used for malting.

A sixteenth-century malthouse can be found in Riverside, EYNSFORD (TQ 5386 6560). This is a timber-framed, two-storeyed, jettied building under a tiled roof. There is no documentary record, apart from Kelly's 1859 and 1867 directories, which lists H. Bellingham as maltster.

A mid-sixteenth-century malthouse is identified in the *Historic Environment Record* at the junction of East Street and Church Street, HARRIETSHAM (TQ 8704 5422). Known as Bell Farmhouse, this is a two-storey timber-framed building of five bays under a tiled roof,

Fordwich malthouse.

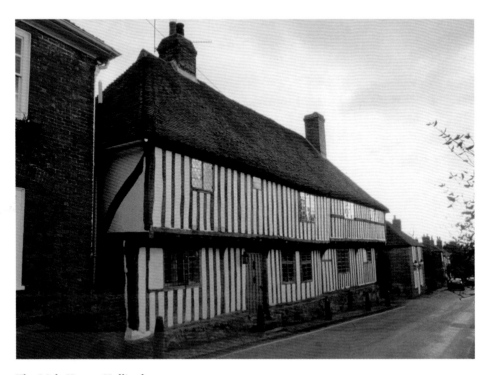

The Malt House, Hollingbourne.

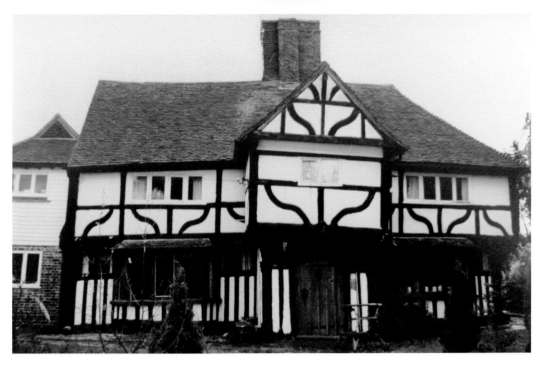

Lynsted malthouse.

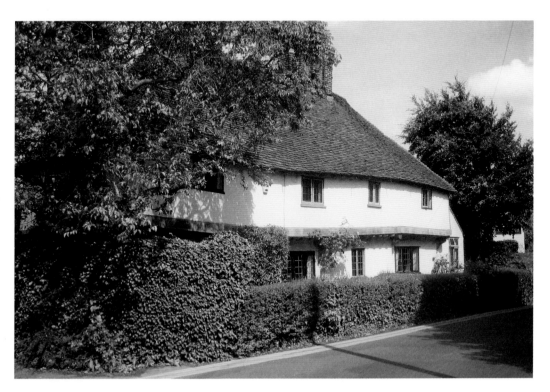

Eynsford Riverside malthouse.

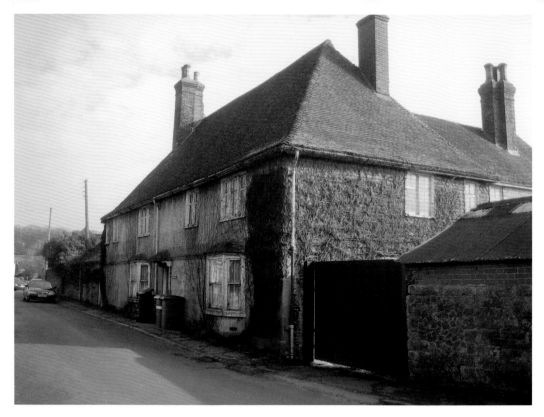

Harrietsham malthouse.

with a twentieth-century cement rendered façade facing the road. A possible square kiln stood at the eastern rear of the building.

At KEMSING (TQ 563 588), at least part of the malthouse dates from the sixteenth century. Here, there is a long range of buildings of varied dates, which were reconstructed into living accommodation in 1938. The long eastern range probably dates from the seventeenth century, with a timber-framed first floor over brick. The mid-section could be sixteenth-century, while the west end could be converted late medieval houses. All malting features were lost during conversion.

At SANDHURST is the Grade II listed Malthouse Farm (TQ 7932 2868), on Megrims Hill. The farmhouse was originally a two-storey timber-framed building of at least the sixteenth century under a hipped tile roof with central chimney stack, with a weatherboard wing to the rear at the west end. The façade was probably altered in the nineteenth century, with a brick lower storey and weatherboard above. A malthouse at this location is marked on the OS first to fourth editions. However, the labelling is somewhat ambiguous, as the farmhouse appears to be marked on the third and fourth editions, while the adjacent oast house, a long rectangular building with two round kilns at the eastern end appears to be the building marked 'malthouse' on the first and second editions. Construction of the oast house is a brick lower storey, with weatherboard above and two brick roundels with revolving cowls, which could have been used for malting. Both buildings have been altered into living accommodation.

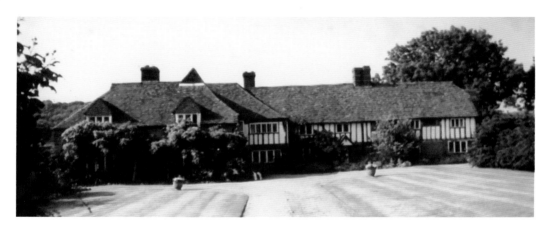

Kemsing malthouse.

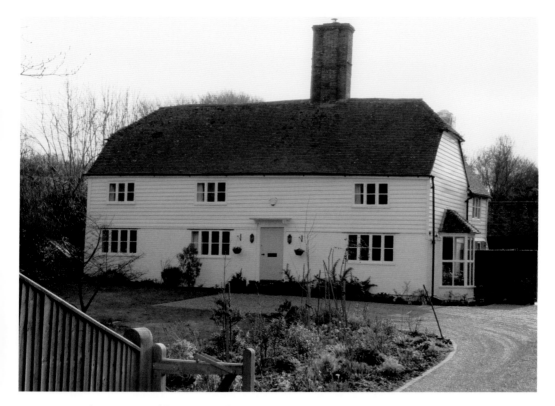

Sixteenth-century malthouse, Sandhurst. Rear wing just visible.

The seventeenth-century malthouse in Hawks Hill Lane, Bexon, BREDGAR (TQ 893 596), had a two-storey red-brick building of three bays under a tiled roof providing the growing floor, with a square kiln supported by large buttresses at the east end. Thatch on the roof is a later addition, as are two bays at the eastern end for either extra growing space or storage. The building has been adapted for private accommodation.

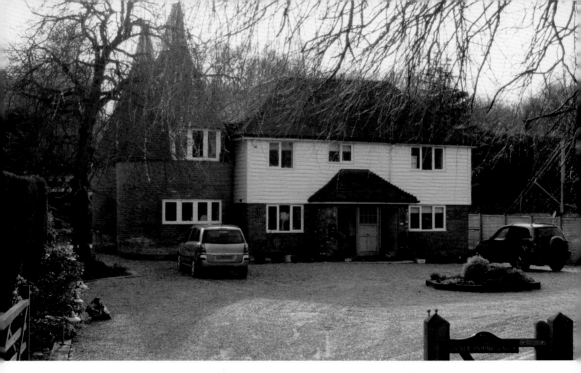

Oast adjacent to Sandhurst malthouse.

At BRABOURNE, the malthouse (TR 0994 4190) appears to be of seventeenth-century origin with later additions. Onslow Andrews is listed as the owner-occupier in the 1841 tithe apportionment (plot 74), with Walter Andrews listed as maltster in Kelly 1867 and 1874. The original two-storey malthouse is a brick buttressed superstructure on a stone base under a tiled roof. The east end, although stone based, appears to have a join in the wall, and is an addition or separate building. The kiln block with a cowl looks to be a nineteenth-century addition, as does the storage area at the west end.

Malthouse Cottage in Mongeham Road, GREAT MONGEHAM (TR 350 516), dates from the seventeenth century, being first recorded in September 1694 when maltster William Beane of Great Mongeham bought Ivy House, together with the malthouse and barn, for £65. The malthouse passed through the hands of the Wildash family of Chatham, brewers, to the Harrison family of Deal in 1800, until last used as a malthouse by the Kingford brothers prior to 1879. The property was then sold to Richard Wilks of Little Mongeham, estate agent, who converted the malthouse into a cottage.

The malthouse stood conveniently adjacent to the brewery in Northbourne Road, Great Mongeham (TR3496 5157), belonging to John Noakes Coleman until bought c. 1860 and operated by William Hills, who also brewed at 28 High Street, Deal. The brewery was bought by Thompson & Son Ltd of Walmer in 1901; it was closed and the buildings demolished.

The Old Malthouse, Malt House Road, STANSTED (TQ 6078 6299), is listed Grade II as seventeenth-century or earlier. It is a two-storey timber-framed building, which still had wattle and daub infill when visited by Arthur Mee in 1939. The red-brick infill is modern. It is possible that a square projection to the rear at the south-east end, which was marked

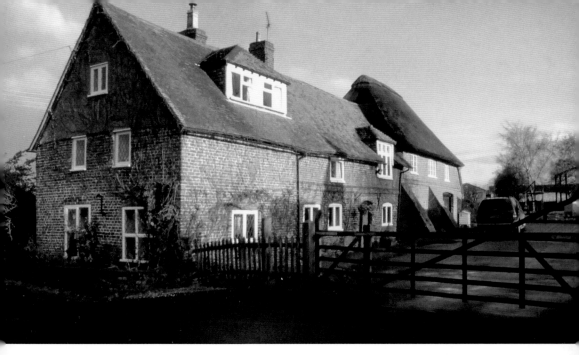

Bredgar malthouse.

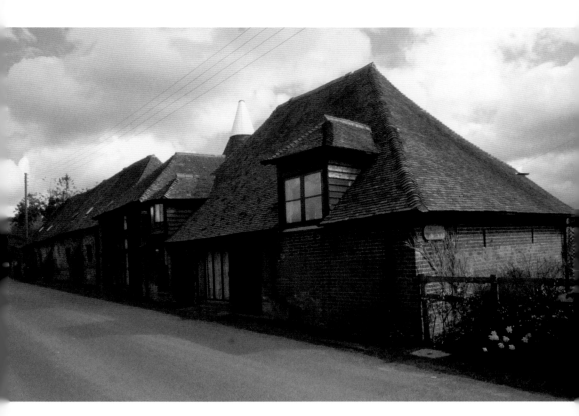

Brabourne malthouse.

Malthouse Cottage, Great Mongeham.

Stansted malthouse.

on the OS second and third editions, had been the kiln. In 1825, buildings in Stansted used as a malthouse with a dwelling house adjoining were leased by Henry Streatfield and his wife Hannah to Edward Lawrence of Stanstead, maltster, for twenty-one years at £90 per annum. However, the tithe map and assessment marked an 'Old Malt House' (plot 158), but recorded the use as cottages with six named occupiers. Now converted into a single, detached house, any malthouse features have been lost.

A building which was adapted to become a malthouse was St Katherine's Chapel at SHORNE. The building would have provided a long, paved growing floor, ideal for malting. There is no record of the date of conversion, which may well have been in the seventeenth century, the chapel having become redundant after the Reformation. Thorpe in his *Custumale Roffense* of 1788 states that, 'Opposite Mr. Maplesden's house (Pipes Place, Shorne) stands an ancient and fair chapel or oratory,' which together with some additional buildings, 'is now used as a malt house, and a small tenement erected against the east end inhabited by the malt man.' A drawing from the 1780s shows the chapel with a cowl on an internal kiln at the east end.

In a marriage settlement between a Jarvis Noakes and Mary Hartridge, dated 24 May 1797, the building is described as a 'chapel or malthouse', which was 'converted into a malthouse with appurtenances adjoining', referring to a cistern and malt mill. However, a lease of 1825, Wells to Jarvis Noakes, refers to a 'dissolved chapel formerly used as a malthouse, cistern and malt mill'. A brick building to the west of the chapel, named the Malt House and shaped as a segment of a circle, has what appears to be a blocked cart entrance, and perhaps two doorways, making this possibly a wagon house and stable, or a grain and malt store. The chapel building has been restored.

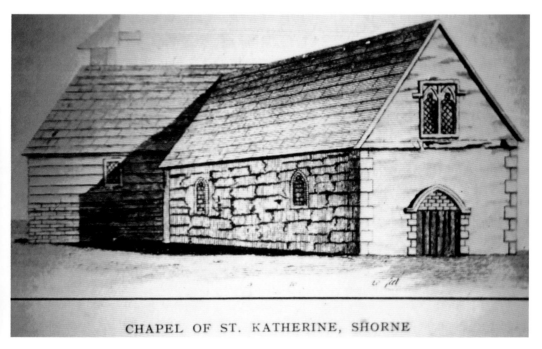

CHAPEL OF ST. KATHERINE, SHORNE

St Katherine's Chapel from *Custumale Roffense.*

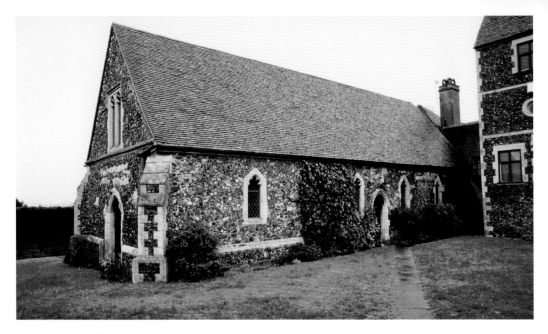

St Katherine's Chapel, Shorne.

The remains of a substantial malthouse stand behind the Tudor House, King Street, MARGATE (TR 3554 7105), which is thought to date to the first half of the seventeenth century. The malthouse formed part of a substantial farm complex, which in 1776 was known as Westbrooke in the parish of St John the Baptist. A map of 1776, when the property came into the hands of Claude Bezenet, marks the malthouse with a malt mill at the north-west corner on an overall site that stretched from King Street back to the cliffs. Constructed in flint on chalk block footings, the east and west walls stand to first-floor level. The two growing floors are marked by characteristic small windows that had wooden lintels with red brick dressings and vertical dividers for shutters. Considering the width of the building, it probably had parallel ridged roofs running north to south, with the kiln at the northern end. No trace of internal fittings remains. The building is not marked as a malthouse on the first edition OS and probably went out of use as a malthouse with the expansion of Cobbs' malting capacity.

One identified early eighteenth-century malthouse survives as a private residence at NONINGTON. The malthouse at Easole Street (TR 2628 5224), dating from 1704, is a two-storey building, the lower storey constructed of brick with a timber-framed upper storey. The roof of the growing and storage area is thatch. It has characteristically small windows and a loading door at first-floor level. There is a brick internal kiln built into a brick extension to the rear. The original owner, William Hammond, sold or leased the malthouse to John Cason and Isaac Casgrove in 1717. Later, named maltsters are: William Osmond Hammond, owner occupier in the tithe assessment; Stephen S. Pain (Kelly, 1859); S. S. Pain & Son (Kelly, 1867 and 1874); John Harvey & Brother (Kelly, 1882 and 1891) and John Harvey (Kelly, 1903), but it is not certain that the malthouse continued in use after c. 1903.

An early eighteenth-century malthouse is identified in the Kent Historic Environment Record in Otham Street, OTHAM (TQ 7972 5329), in the grounds of a house called Belks.

The west wall of the malthouse in King Street, Margate.

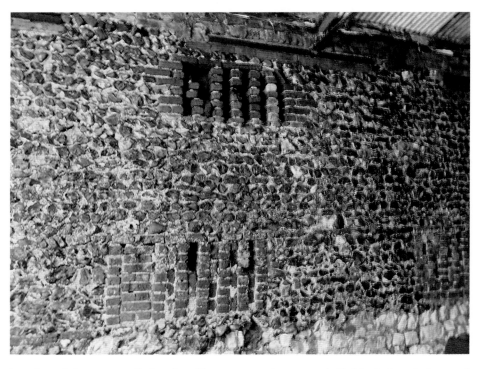

Interior of the west wall showing flint construction on a chalk block foundation, and vertically divided windows.

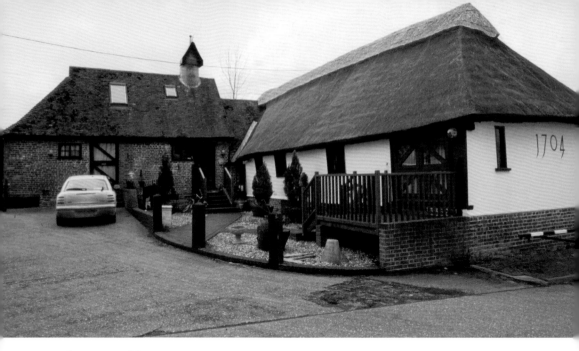

Easole Street malthouse, Nonington.

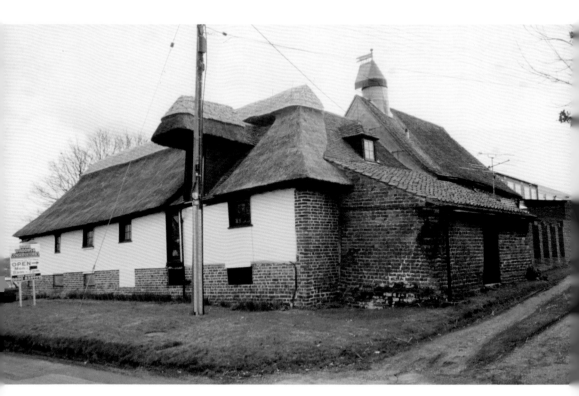

Easole Street malthouse showing characteristic windows to two growing levels, and loading door to loft storage.

The two-storey building was L-shaped, standing on a rag-stone base and constructed of brick to the front with a stone ground floor, with timber over to the rear, under a tiled roof. It originally had a large square kiln. However, by the second edition OS this was replaced by a round kiln to the north-east. There appears to have been a change of function to hop oast and store, probably about 1880 when hop production was at a high point. The building has been altered and truncated, but remains substantially whole. The tithe survey of 1838 records the owner-occupier as Henry Simmonds.

The substantial malthouse in West Street, WEST MALLING (TQ 6779 5777), is an eighteenth-century building with two ranges of two storeys parallel to West Street. It is built of brick at ground-floor level, with a timber upper floor under a tiled roof and with three loading doors onto the street. The range fronting West Street has a single internal kiln, and the northern range three internal conical kilns. The building was converted into shops in the nineteenth century, with the upper floor supported by cast-iron pillars to form an arcade. The only known maltster is Henry Dickenson, a West Malling brewer listed in Pigot, 1824, and Kelly, 1859, directories.

At OFFHAM there is a building named The Malt House which could have been an eighteenth-century malting, but there is no supporting documentary information.

The malthouse of eighteenth-century construction at KINGSDOWN, Sittingbourne (TR 9314 5965), is built with red and blue brick under a tile roof. It is recorded in the 1835

Otham malthouse, with the buttressed wall of the original square kiln.

Otham malthouse viewed from the east with round kiln.

West Malling malthouse, with kilns just visible and with loading doors above the shops.

Offham malthouse.

Kingsdown malthouse.

tithe survey for Bapchild as a 'malthouse, cottage and meadow', owned by Col. Tyler and occupied by Edward Strouts. Also marked on the first to third editions OS the building was rectangular, aligned east to west, with what could have been a square kiln to the rear at the north-west end. The maltsters associated with Kingsdown are John Stevens Snr and Samuel Stevens in Melville 1858. The building has been converted into a dwelling house.

The outline of an eighteenth-century malting can be traced at Wincheap Street Maltings, CANTERBURY (TR 1445 5730). This malthouse has been demolished apart from the north, east and west brick walls, which stand to ground-floor window height enclosing the car park of the Maiden's Head public house. This is William Rugly's malthouse, listed in Pigot 1824 and Bagshaw 1847.

The Malt House, Tenterden Road, BIDDENDEN (TQ 8507 3813), listed Grade II, is an eighteenth-century, two-storey building under a hipped tile roof. This building was much altered to form a dwelling house. When it was converted is uncertain, but it is not listed as a malthouse in the tithe assessment.

A possible late eighteenth-century farm malting stands at Court Farm, STANSTED (TQ 608 621), which would also have served as a hop oast. It is of brick and flint construction under a tiled roof, with one round kiln. Standing at the east of the farmyard, this building shows signs of adaption from the eighteenth century onwards.

Biddenden malthouse.

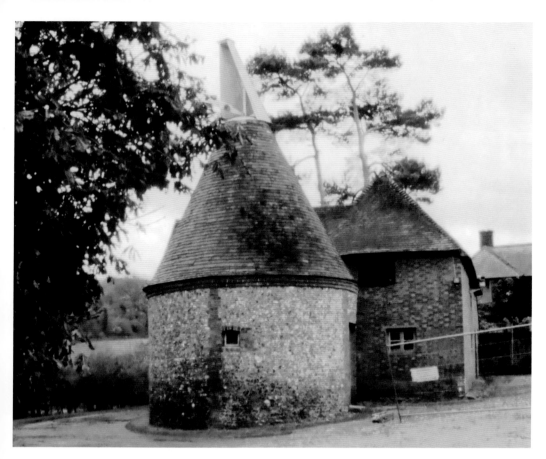

Malthouse at Court Farm, Stansted.

The maltings in Eynsford Road (TQ 5481 6657), FARNINGHAM, replaced a building destroyed by fire *c.* 1781 when they were operated by Richard Mullens and James Collins. By 1840 the rebuilt maltings came into the possession of, and were operated by, the Fellows family, William Henry Fellows being a maltster, paper manufacturer and corn miller who is listed in Kelly until 1867. The building had gone out of use by the 1881 Census, when it is described as 'Old Malthouse'. The maltings, which probably had an external kiln to the rear, were converted into three units of accommodation in the late Victorian era.

CLIFFE malthouse in Church Street (TQ 7356 7642) probably dates from the eighteenth century. The two-storey building is constructed partly of brick, but part has timber framing and is now substantially covered in weatherboarding. There is what appears to have been provision for a lucam and loading doors in the south aspect. A 'Malthouse Farm House Premises and Garden' (Plot 439,440) are marked and listed in the tithe map and assessment as occupied by James Steer. It is marked on the first (1860) and third (1908) editions of the Ordnance Survey 25-inch maps, but there is no further record of its operation. It is now a private house.

The substantial remains of a malthouse stand on the east side of Mongeham Road, GREAT MONGEHAM, which was associated with the adjacent manor house. The property was owned in the early eighteenth century by Samuel Shepherd, who built the first malthouse

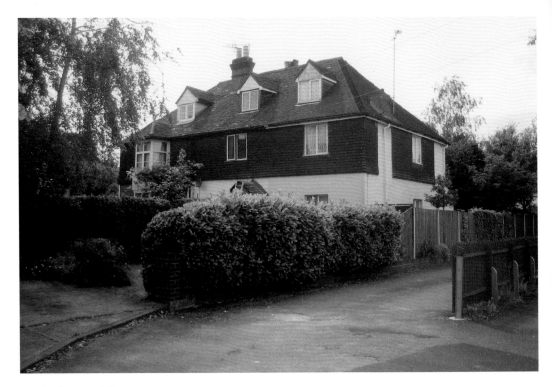

Farningham malthouse.

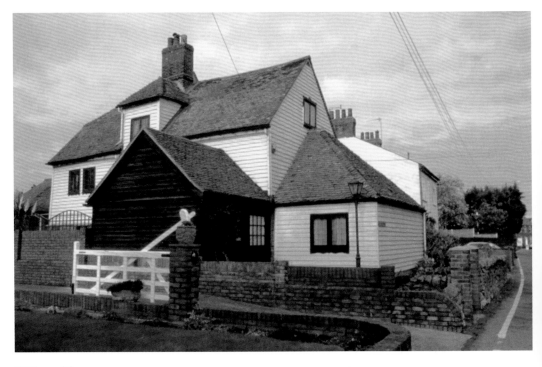

Cliffe malthouse.

before moving to Faversham. The malthouse was built in red brick with characteristic small windows, some of which survive. In 1775 the property was bought by Admiral Bray, who supplied local brewers such as T. Russell, Castle Brewery, Dover. His granddaughter, Margaret, ran the maltings with an employed maltman until 1883, when the malthouse was leased to Thompson's of Walmer. The malthouse stood on the opposite side of Mongeham Road to Hill's Brewery, which was partially thatched. It was substantially destroyed by fire in October 1877 when embers from a fire blew across the road, setting fire to the thatch on its roof. The building was insured and was rebuilt in brick from just above the ground-floor window level as a two-storey building. The line from which rebuilding took place can be traced in the brickwork. As rebuilt, it has loading doors and storage for grain and malt at the north end.

The Malt House and Malt House Barn stand at the head of Malthouse Lane, TENTERDEN. The malthouse is constructed of red and blue bricks under a tiled roof, and appears to have had a loading door, since blocked, to the upper floor. The windows are modern inserts and the weatherboarding may not be original. There are references to a malthouse in Tenterden from 1714, which presumably supplied the Tenterden Brewery located in Station Road, which at one time was owned by Samuel Shepherd and was operated by Obadiah Edwards & Sons in the late nineteenth century, but which did not have its own malthouse.

At BOUGHTON ALUPH (TR 0272 4771) is an example of a small malthouse associated with an equally small-scale rural brewery, in use in the eighteenth and nineteenth centuries. It is marked on the first edition OS as two buildings, with construction dating from the sixteenth century for the right-hand unit and the eighteenth century for the left unit. The sixteenth-century part (storage/growing floor area) was a jettied timber-framed building

Bray's malthouse, Great Mongeham, seen from the north and showing the storage area.

Different coloured bricks indicate the area rebuilt at Bray's malthouse.

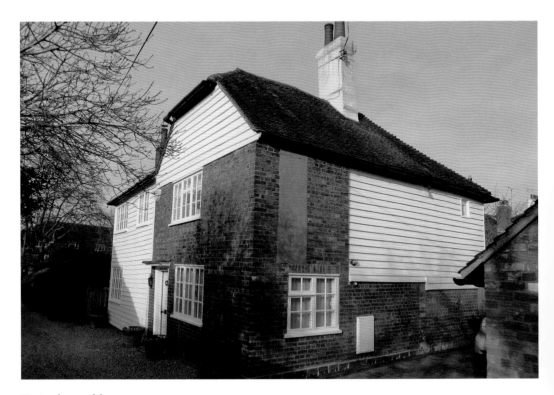

Tenterden malthouse.

Boughton Aluph malthouse.

The kiln end at Boughton Aluph.

Malthouse cottages, Boughton Aluph.

now with a brick skin at ground-floor level and a tile-hung first floor under a hipped tile roof. The eighteenth-century section was brick built under a tiled roof (probably the kiln end). The building appears to have provided malt for the brewery owned by the Hobday family, which stood in the adjacent lane. As the malthouse stood in a relatively isolated location, workers' cottages (Malting Cottages) were provided adjacent to the west, three cottages appearing on the second edition OS.

When the buildings were originally used as a malthouse is unclear, as the only documentary evidence comes from the nineteenth century, firstly with the tithe assessment listing Richard Taylor as owner-occupier, and Kelly 1855 and 1859 listing William Hobday as brewer and maltster and Mrs E. Hobday as a maltster, while in 1867 R. Hobday is listed. Malting presumably ended soon after, as there are no further listings for this site.

Nineteenth-century malthouses

What appears to be an oast converted in recent times to accommodation is identified as a malthouse in the Kent Historic Environment Record at the junction of Littlebourne Road and Stodmarsh Road, LITTLEBOURNE (TR 1735 5786). Dating from 1836, this two-storey building with loft storage has slate ground-level floors, which would be unnecessary if it were to be used solely for kilning hops.

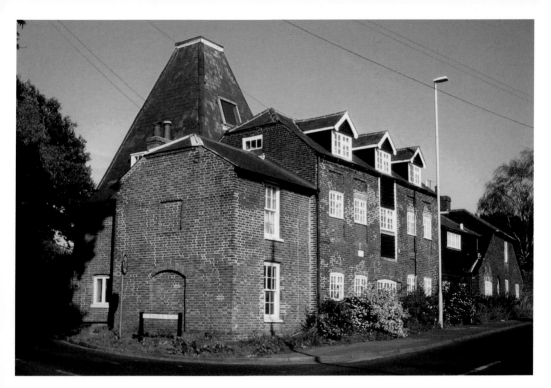

Littlebourne Oast.

The nineteenth-century maltings at WROTHAM (TQ 6252 5884) are of the common two storey type. The construction is a lower floor of ragstone, and an upper floor in brick under a tiled roof with one square brick kiln under a pyramidal roof. There is a timber house behind the maltings. All the elements appear to be of different dates. The maltings were associated with the Nepicar Brewery, situated on the opposite side of the A20, which was set up by Jonathon Biggs in 1840 who left the brewery in the hands of his sons when he relocated to Strood. The Nepicar Brewery passed into the hands of C. G. & J. M. Reed, was bought by Walter Morgan *c.* 1880, and was finally purchased by Golding & Co. of Sevenoaks with brewing ending in 1912, after which the brewery was demolished and malting presumably ceased.

An example of a small, nineteenth-century farm malting can be found at AYLESFORD. Located at Anchor Farm (TQ 7358 5965), this is a two-storey brick building with loft storage, which has one round kiln that is joined to the growing/storage area by a short link. It is possible that this was a farm malting, which could be alternatively used as an oast, and may have been associated with the Anchor Brewery, Aylesford. It has now been converted to living accommodation.

Malthouses built up to the middle of the nineteenth century were characteristically of two storeys. The kilns followed the pattern of oast houses being square with a pyramidal roof in the first third of the century, changing to round kilns in the middle years, before reverting to square. Most were topped with a conical cowl. Early examples are generally of relatively small capacity.

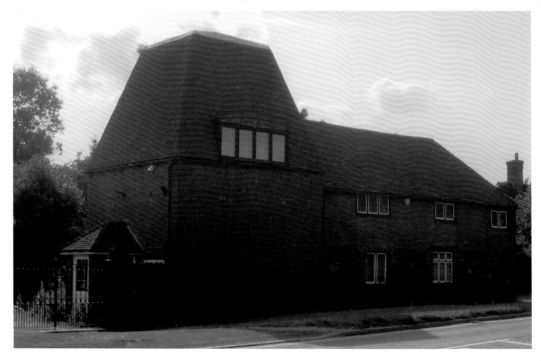

Wrotham malthouse.

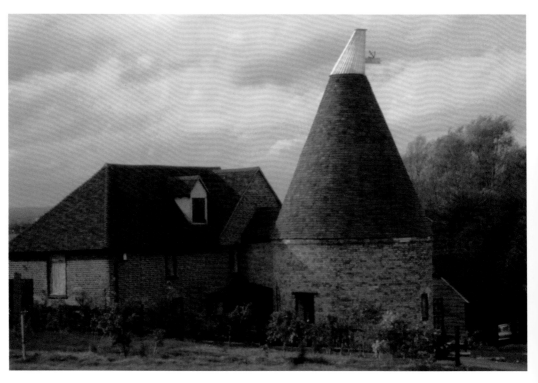

Anchor Oast, Aylesford.

The Malt House at BOXLEY (TQ 773 589) is an unusual two-storey building, probably dating from the 1830s. The construction is in red brick at ground level, with a chalk block upper floor under a hipped tiled roof. The first floor, as well as the ground floor, was tiled as a growing floor with timber support columns. Storage was in the loft. Hoppers lined one wall at first-floor level, constructed of timber and lathe and plaster, while a steep of rendered brick stood on the ground floor. There is a square kiln to one end. There is a small range joining the kiln at 90 degrees, making the maltings L-shaped with a second kiln at the end, which is likely to be late nineteenth-century. It is possible that this is the malt house operated by T. Filmer listed in Piggott 1839, and by Mark Atkins (also at Boughton Monchelsea) listed in Melville 1858 and Kelly 1859 and 1867. By 1874, Kelly listed Mark and William Atkins, but in 1882 only William Henry Atkins. The last entry for Boxley in Kelly 1903 is for Charles Frederick Foster. During the early 1900s the building was used as a hop oast. It has now been converted to accommodation.

Another small malting from the first half of the nineteenth century was at Boroughs Oak Farm, Hale Street, EAST PECKHAM (TQ 673 498). The malting formed part of a farm complex that has now been converted into housing. Almost square in plan, it was of brick construction under a tiled roof, and built pre-1842 as it appears on the Tithe Map. It was converted to an oast pre-1908 with added kilns, six appearing on the 1908 OS map, one now remaining after conversion to a house. Kilns at the west side had pierced tiled drying floors, which indicate that these were in use for malting. Another building on site was said to have served as a farm brewery pre-1914.

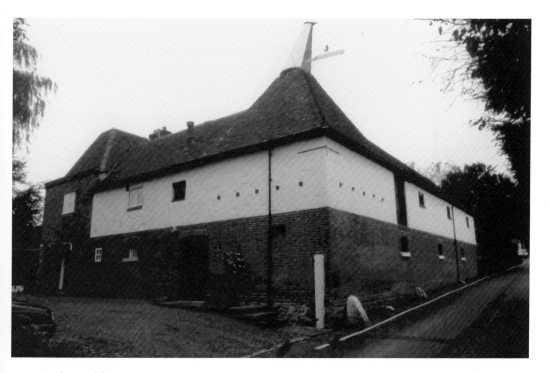

Boxley malthouse.

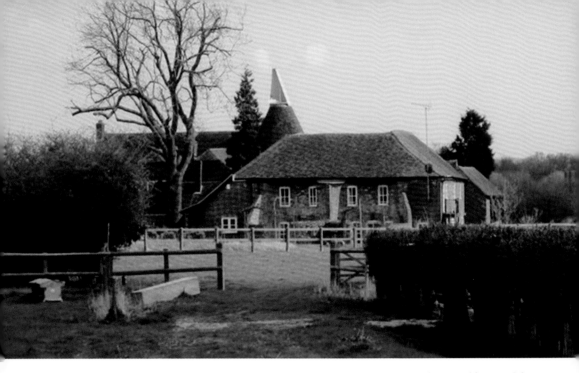

Lucks Oast, Borough's Oak Farm, East Peckham. (Copyright Oast House Archive and licenced for reuse under Creative Commons Licence.)

A farm malting is located at Four Wents, CRANBROOK (TQ 7529 3760). It appears to be a nineteenth-century two-storey building, constructed in brick under a tile roof with two square kilns. No detail is available as to its history.

A larger two-storey malthouse survives at HYTHE (TR1595 3476), which was associated with Henry and William Mackeson, who bought the brewery standing adjacent to the west in 1801. The malthouse, which stands on the corner of High Street and Malthouse Hill, is constructed with a stone west wall, but otherwise is brick with decorative arcading to the front. The lower flooring is concrete and the upper flooring timber, with slender iron columns supporting the first floor and roof. The demolished square kiln stood adjacent to the building at the south-east corner by High Street, an area now used by a café.

The Mackesons remained in control until 1920, when Simmonds of Reading acquired the firm to be sold in 1929 to Jude, Hanbury & Co., by then a subsidiary of Whitbread. The brewery site was cleared for housing after brewing ceased in 1968. The building has been used as an antique/flea market since 1974.

Dane John Maltings, Gordon Road, CANTERBURY (TR 1479 5718), is a nineteenth-century conversion of a late medieval building lying to the west of Canterbury East railway station, which probably formed part of the Dane John Manor. The building in red brick retains stone mouldings round both windows and door. The building has been made into two storeys, and two square kilns with pyramidal roofs have been added. A lucam and loading doors are located at the gable end. It is assumed the malthouse was associated with the nearby Dane John Brewery. The building is now used as an office.

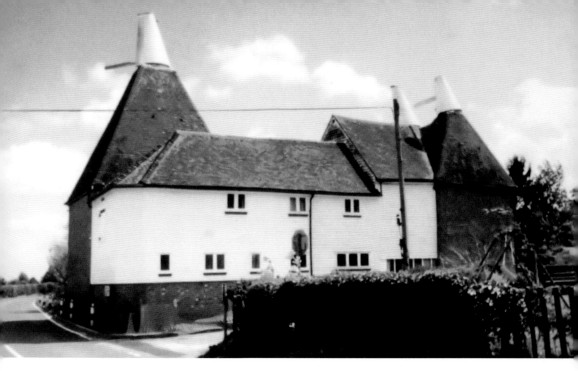

Four Wents malthouse, Cranbrook.

Mackesons' Hythe malthouse.

Above: Dane John malthouse, Canterbury.

Left: Dane John malthouse viewed from the east showing the inserted loading door and characteristic small windows inserted for the growing floor.

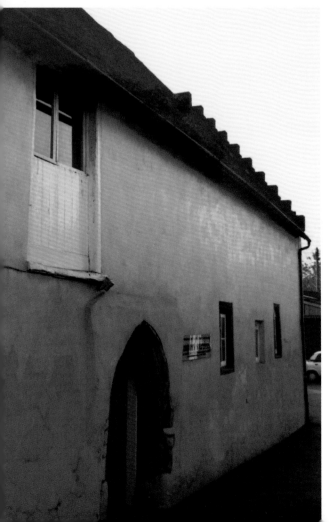

Retained medieval doorway giving access to the growing floor, Dane John malthouse.

Oaten Hill Maltings, CANTERBURY (TR 152 574), is a nineteenth-century, two-storey, red brick, parallel range malthouse, with two square pyramid kilns with revolving cowls and loft storage. There are loading doors at each level facing Oaten Hill. By its shape, it appears to have been built to fit an available odd-shaped plot on the corner of Oaten Hill Place. It is not known who operated these maltings.

The Baker's Cross Brewery, CRANBROOK (TQ 7813 3582), was bought by William Barling Sharpe in 1845, before becoming listed as Sharpe & Winch between 1899 and 1913. It was acquired by Leney & Sons in 1928 and demolished in 1938. The maltings are of the nineteenth-century, two-storey type of seven bays, constructed in brick. The windows are altered to facilitate alternative usage as a joinery, and the kiln has been demolished.

Style Place Brewery, HADLOW (TQ 6460 4900), was the smaller of two breweries to operate at Hadlow, being located to the south of the parish. It was run by Henry Simmonds up to 1852 when he went into partnership with William Martin. The malthouse first appeared on a map of 1832 and shares many characteristics with malthouses common from the eighteenth through to the late nineteenth century. It is a brick-built structure under a slate roof on a ragstone plinth, rectangular in plan with a two-storey range of eight bays with loft and basement. The kilns have since been removed, but appear on the 1908 edition Ordnance Survey as two pairs of circular kilns. The flat wall surface is punctuated only by characteristically small segmental headed windows. A mixture of red and blue bricks was used randomly in the wall construction. The loft floors are timber and the first floors are supported on cast-iron pillars. Like No. 3 Malthouse at the Close Brewery, the basement is brick vaulted with cast-iron pillars. The first floor and loft floor would have provided storage, while the basement would have been a brewery barrel store. There is a single loading door on the ground floor, two above on one longitudinal side and one at first-floor level on the

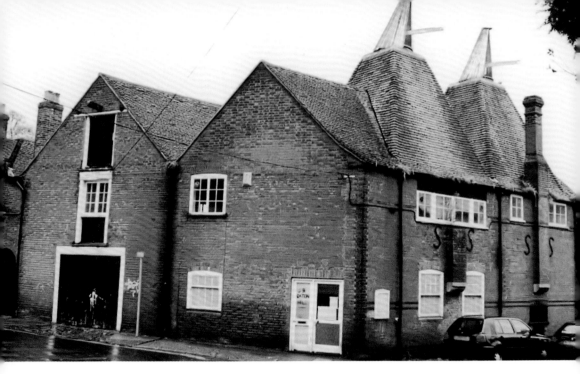

Oaten Place malthouse, Canterbury.

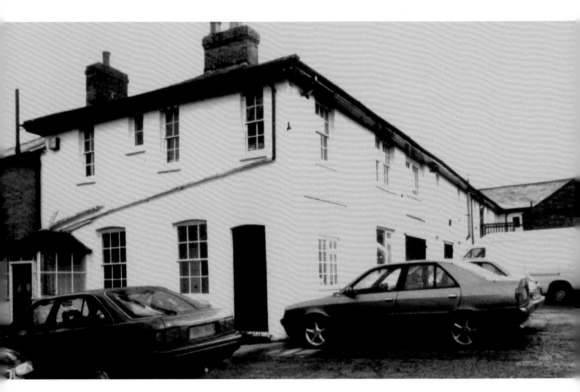

Bakers Cross malthouse, Cranbrook.

opposite side. The firm, run by Henry Simmons and William Martin until 1863 when Martin retired, was relatively small, supplying seven public houses and five beer shops.

The valuation inventory is of interest as it enumerates the complete equipment of a malthouse. In the malt loft: a pair of steel yards; four old tubs; old shrouded rigger; a quantity of cast-iron false bottom plates; two oak planks; two pairs of men's clogs; two oil cans; an iron wire sieve and 175 four bushel sacks. In the loft above the malt hopper: raised stage and steps to malt hoppers. On the malt floor: iron gauge rods; two couch levellers; old tubs (presumably for water); old dray tilt; two small wooden stirrers; seven wooden shovels; four steps and risers descending to the stoke hole. In the stoke hole: water can; three stoking irons; wrought-iron draught plates; furnace bars; mouth plate bearing bars in the furnace; iron shovel; deal bench and two oil lamps. In the storeroom over the malt floor: wire malt screen with hopper head and canvass bagging; two wicker baskets; a bushel measure with iron ears; a small barrow on iron wheels; three short ladders up to hop kilns; one puncheon, one hogshead and one barrel stand; an eighteen-rung stout step ladder to yard, with hooks and handrail. Above the loft: a Boby's patent barley screen; a wood-hoisting drum with fly wheels handles; length of rope with sack chains and wood wheel guides. In the kiln: a nine-step ladder thereto; sliding doors in grooves to the kilns; chains and pulley weights; slight shifting boards to doorway; large wooden rigger overhead with length of rope for hoisting grains to the kilns; two ladders. Also included in the valuation were the cost of nails and labour on the erection of malt bins and cast-iron columns for supporting the bins.

The brewery was then run by Henry Simmonds Jnr until 1905 when it was bought by Style & Winch of Medway Brewery, Maidstone, and closed down.

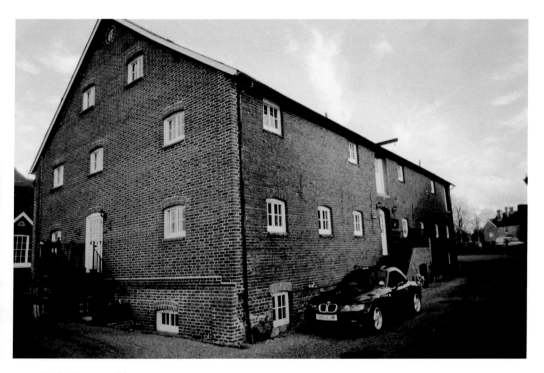

Style Place malthouse.

William Martin also had an interest in neighbouring Boormans Farm, HADLOW (TQ 6465 4950), located on the opposite side of Court Lane to Style Place. Here there was another malthouse, as well as oasts for drying hops. In 1863 the malthouse was equipped with 'four oast hairs to sixteen feet circles' (horsehair mats, which were laid over the slatted floor above the furnace in the kiln, and upon which the hops were heaped for drying), three rakes, two shovels, two stokers, two scale beams and seven hop scuppets, and appears that it was being used as an oast, but could well still have been used for malting pale malt given the interchangeability of oasts and malthouses. The present building on the site appears to be an oast with four round kilns converted to living accommodation, which could easily have evolved from the malthouse.

The malthouse that stands behind cottages at Moat Sole, SANDWICH (TR 3283 5808), has two storeys and is constructed in brick with one square kiln. By the 1920s, the East Kent Brewery in Strand Street had been relegated to use as a mineral water factory, and the malthouse put up for auction on 21 May 1924. The malthouse survives as a commercial building.

The surviving malthouse in Cave Lane, GOODNESTONE (TR 2591 5523), dates to the mid-nineteenth century. The building is of two-storey red brick construction under a slate roof. There are two square kilns with pyramidal roofs. George Hatcher is listed as the maltster in Melville 1858 and Kelly 1882. The building was used as a hop oast towards the end of the 1800s.

At BOUGHTON MONCHELSEA the Atkins Maltings, Beresford Hill (TQ7692 5181), represent a successful independent malting operated by Mark Atkins, who is listed in Kelly from 1874 to 1922. The Atkins family appear to have been successfully associated with maltings in several parishes. This malthouse, probably built in the early 1870s, is unusual in that it is constructed of rag stone from the quarry owned by Atkins nearby. It has red brick dressings and a tiled roof. Of two storeys, it has a storage block at one end and one

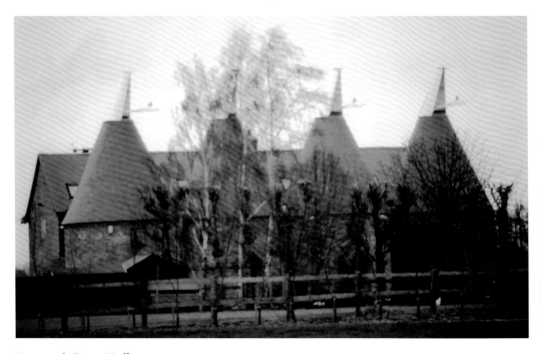

Boorman's Farm, Hadlow.

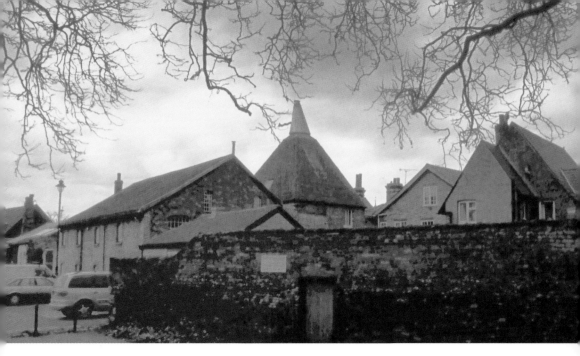

Moat Sole malthouse, Sandwich.

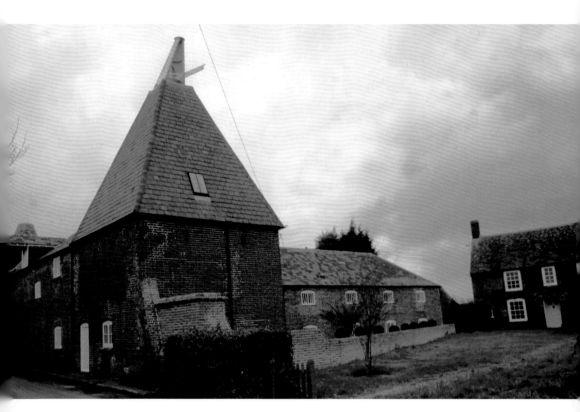

Goodneston malthouse with Malt Cottages.

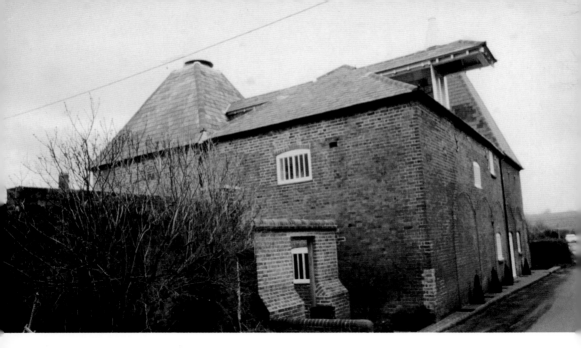

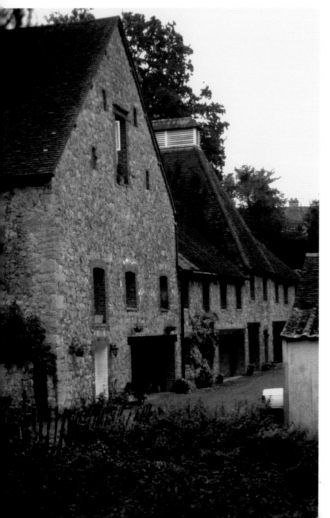

Above: Goodneston malthouse from the west.

Left: Atkins Malthouse, Boughton Monchelsea.

square kiln with a pyramidal roof at the opposite end. The malthouse has been converted into housing. It is unusual not only in the material of its construction, but also in that it is of relatively small capacity at a time when large multi-floored maltings were being built.

The Cannon Brewery, High Street, RAMSGATE (TR 3789 6515), had a larger version of the two-storey malthouse adjacent to the brewery. Built of yellow brick in twelve bays, with loft storage under a slate roof with dormer windows, it has two square red brick kilns under pyramidal roofs, which are attached to the side at the west end. The maltings, which have been converted to accommodation, were run by Robert Cramp & Sons until acquired by Tomson & Wotton in 1878, with brewing continued on site until 1920.

At LENHAM FORSTAL (TR 913 503), a brewery and malthouse were established by a Mr Mercer in 1785, which was acquired in the 1830s by Thomas Chapman. Chapman transferred the brewing operation to the Lion Brewery, Ashford, which he purchased in 1868, while retaining the malt operations at Lenham.

Cannon Brewery malthouse, Ramsgate.

Cannon malthouse from the west.

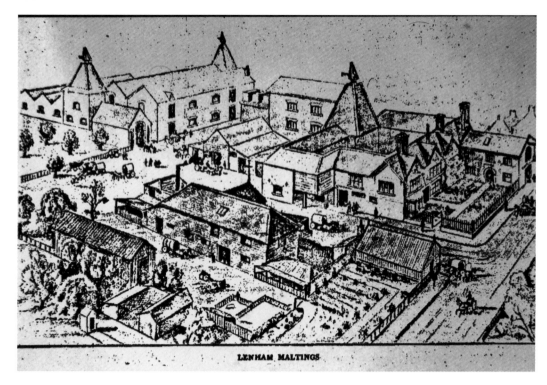

Chapman's Lenham maltings at Lenham Forstal. (Barnard, *Noted Breweries of Great Britain*)

The maltings were described by Barnard in *Noted Breweries of Great Britain and Ireland* (1890, 207–8) when there were three ranges with three kilns attached, built of stone under slate roofs, plus several stores; the malt office was to the right of the front of the complex.

The original 15-quarter malthouse (behind the house) had two growing floors and a kiln laid with perforated tile with a stone steep. The upper growing floor had cemented on slates, the whole being supported by iron columns. Attached to the kiln were two malt stores and a spacious barley loft, below which was a malt screening room.

Malting No. 2, built in 1871, was two storeys with a 17-quarter capacity. The growing floor was 87 × 60 feet with floors of cement and the steep of brick and slate. The top floor was divided in the centre and used as stores for barley and malt.

No. 3 malthouse was built in 1877 with a growing floor, divided by party walls, measuring 143 × 53 feet, and a capacity of 21 quarters. Its three roofs were lined with match boards. The barley fell from shoots through a hanging screen (for final cleansing) into the cistern. The barley garner, capable of storing 1,000 quarters, was lined with pine. The kiln was similar to No. 2, containing a brick heating chamber 9 feet below the surface, over which was a drying floor of Farnley tiles.

Malt was made for the Lion Brewery, Ashford, and for several London breweries after 1898, but closed *c.* 1912 when Style & Winch purchased the brewery.

Larger-scale two-storey malthouses such as at the Cannon Brewery were constructed by brewers after 1850. Another example was Shepherd Neame's Preston Maltings, FAVERSHAM (TR 0181 6088), built in 1858 at a cost of over £2,000. The maltings were

Fragments of the north-end façade of No. 3 Lenham malthouse, which has been substantially demolished, can be seen from Castle Lane.

conveniently situated beside the railway, with a siding for the import of barley. These two-storey buildings are something of a transitional design, utilising both the ground and the upper floors as growing areas to expand production, but corresponds to the 'Two Floor Pattern' identified by Patrick (1996), a form which is most dominant in East Anglia.

The building is of two parallel ranges, sixteen bays long, constructed in yellow stock brick using the pillar and panel method. The usage of the malthouse is divided vertically. At the north-east end were four circular plan kilns that served the thirteen bays of growing floor, two kilns for each floor. The pair of kilns serving the lower growing floor had furnaces in a basement so that the drying floor was level with the growing floor. The final three bays at the south-west end of the structure housed the barley store at first-floor level and steep on the ground floor. The timber upper floor, supported on cast-iron pillars, was likely to have been covered by concrete. Lean-to malt storage built around the kilns has been removed, although traces are still visible. The maltster's house was at the western end of the complex. The maltings, in use until the 1970s, have been converted into living accommodation.

Multi-floor malthouses were built from the late 1850s with good examples surviving at the Close Brewery, HADLOW (TQ 6320 4975). A malthouse is first recorded in 1710 at Hadlow, built by John Barton Snr of The Close, which remained in the ownership of the Barton family for more than 100 years. In 1851 the brewery was in the hands of William Harrison, who from 1852 ran the firm as the partnership of Harrison & Taylor until 1858 when Edward Kenward of Marden and William Barnett of Willingdon, Sussex, took over. Thomas Simmonds of East Peckham and Nelson Kenward also bought into the business.

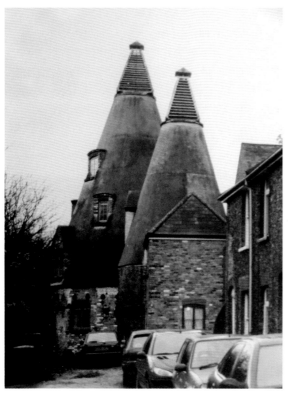

Above: Preston malthouse, Faversham. From left to right are kilns, growing floors, grain store and malt man's house.

Left: Preston malthouse. Kilns serving the lower growing floor. Lean-to malt stores have been removed.

Under the new management the brewery looked to expand, and, as a result, in 1859 a second malthouse, No. 2 Malting, was built parallel to the high street and adjacent to the existing malting, which was subsequently demolished. It is of three storeys with loft storage and a basement. The functional arrangement of the building is typical of a multi-storeyed malthouse, which became common from the 1860s onward. The building was constructed using yellow brick with red brick margins, surrounds and courses separating each storey. The floor plan is rectangular of six bays with twin square kilns at one end. The storage in the loft space is demonstrated by the lucam and by the dormer windows. The barley and malt would have been cleaned on the upper floors, the steep placed on a lower floor at the opposite end to the kilns, and the growing floors would have been the lower floors. The basement in this case may have served as a store. The kilns were fed by elevators from the growing floors. The floors were timber with cast-iron column supports. The building was financed to the tune of £350 by Thomas Simmonds. It had a capacity of 15 quarters, typical of many Kent malthouses, which would have provided sufficient malt for about eighty barrels of beer per week.

Trading after July 1868 as Kenward & Court, the expansion of sales lead to a second 'extensive' malthouse, No. 3 Malting, being constructed in 1880. In many respects the basic form of this malthouse mirrors the earlier No. 2 Malting, but with a number of embellishments. It is rectangular in plan with a three-storey range of ten bays and a pair of square kilns at one end. The wing, at right angles to the main building, is a later addition, and from evidence on

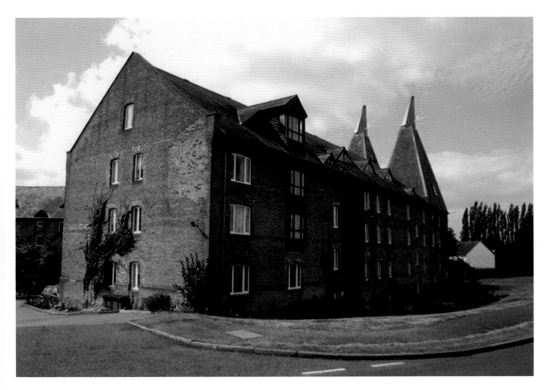

No. 2 Malting, Hadlow. (Copyright Oast House Archive and licenced for reuse under Creative Commons Licence.)

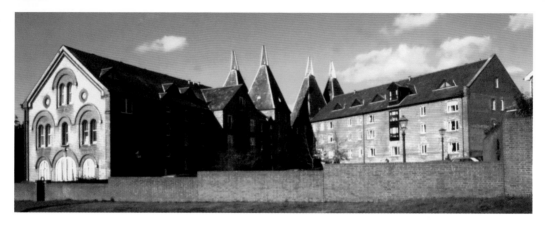

No. 3 Malting, Hadlow.

the façade was used as a loading bay with lucam. A projecting structure on the north-east side of the building, now removed, may have been the original loading bay. At the centre of the building, a tower rising above the roof housed the elevator shaft. The ground-floor ceiling has brick vaulting on cast-iron columns. The south gable end is highly ornamented with rubbed brick windows with paired arches, formerly entrances, and bullseyes openings above. This gable end faces the main road through Hadlow and was clearly a show of wealth and prestige.

The brewery was acquired by Charles Hammerton & Co. Ltd in 1945 with forty public houses, the last beer being brewed on site in September 1949. In 1952, the site was bought by Watneys and then sold on to Charringtons, who continued malt production for their Mile End and Walmer breweries until the late 1950s. The malthouses are now apartments.

The surviving malthouse at St Dunstan's, CANTERBURY (TR 1433 5832), is an example of the large-scale multi-floor maltings coming into use by the third quarter of the nineteenth century. St Dunstan's Brewery and its associated malthouse were owned by the Flint family from 1780 until sold to Alfred Leney & Co. Ltd of Dover in 1923 and closed in 1929. The one surviving malthouse on the north side of Roper Road was constructed with three storeys and a loft in brick under a slate roof. The maltings were equipped with two square kilns at the north end. The ground floor was concrete and the upper floors supported on iron pillars and beams. Lucams were built in at roof level serving loading doors on each level. The loft was timber floored and would have provided storage space. The building has now been converted to apartments.

A second large malthouse behind the St Dunstan's Brewery is marked on the first to third editions OS. Bigger than the surviving malthouse, it was a long rectangular building, lying roughly NE to SW, with its kilns probably at the north-eastern end and the malt storage at right angles to the kilns. When this malthouse went out of use is unclear, but its footprint may well be that of the present industrial building on the site.

Rigden's Brewery in Court Street, FAVERSHAM (TR 0174 6152), was founded in the early eighteenth century by Edward Rigden. It remained in the family, becoming a limited company in 1902, before merging with George Beer & Co. Ltd of Canterbury in 1922. Acquired by Fremlins in 1948, and in turn by Whitbread in 1968, brewing finally ceased in 1990. The brewery always had its own maltings, including an L-shaped malthouse with two

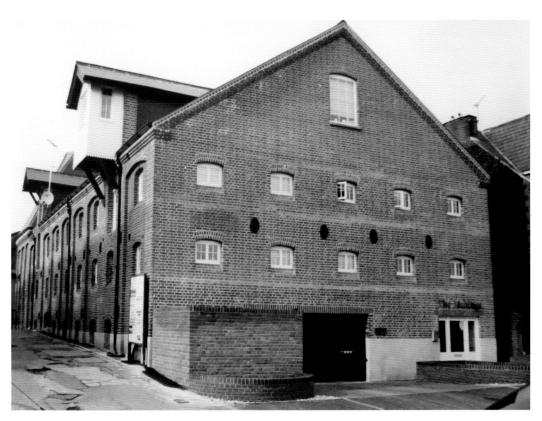

St Dunstan's malthouse from the south.

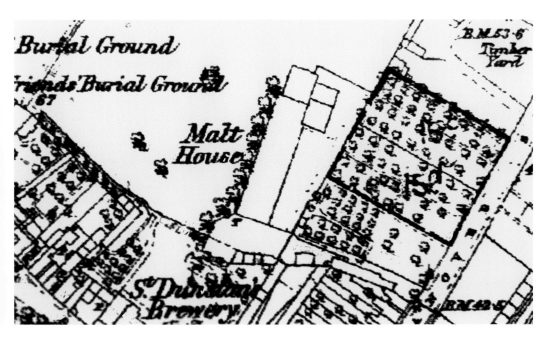

Malthouse marked on the first edition Ordnance Survey at St Dunstan's.

circular kilns marked on Ordnance Survey maps standing in Partridge Lane (TR 0166 6135), and demolished in the twentieth century. A new malthouse was built in 1884 to the designs of professional architect Richard Waite of Duffield, Derby. This much larger four-storey structure, of two parallel ranges of sixteen bays, was built in red brick using the pier-and-panel construction technique. The lower three floors to the west of the kilns were the growing floors, with a cast-iron steep on the third floor and barley storage on the top floor. To the east of these are the three square-plan kilns, which originally had wire kiln floors and wooden cowls, and, past these, the malt store at the eastern end of the building, which originally had malt bins on the first and second floors. The growing floors are concrete supported on cast-iron columns. The barley store on the upper floor, by contrast, was constructed from timber as being better for dry storage. The lucam to hoist the grain to the store has been removed. Elevators and conveyors were installed after 1891 to facilitate the movement of malt within the growing floor and kiln area, and between the malt store and the brew house. A barley kiln was built after 1896 for drying barley before lifting to the barley store. The building is currently used as a Tesco store, and its external features have largely been preserved.

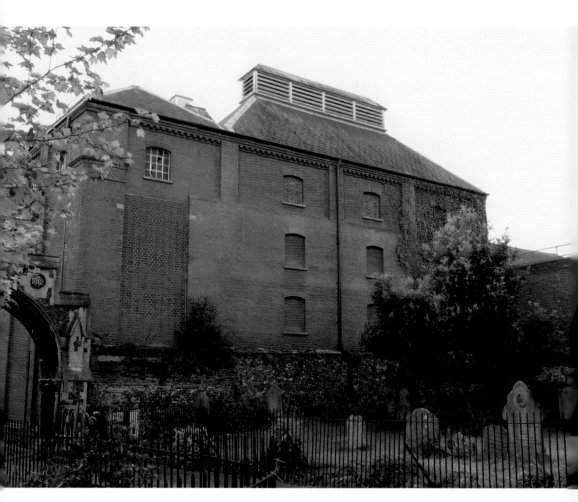

Kiln and malt store, Rigden's.

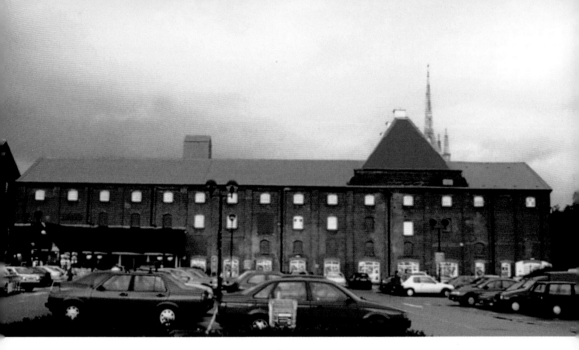

Rigden's malthouse of 1884, now a Tesco supermarket.

A brewery in West Street, GRAVESEND (TQ 6454 7446), was sold by Messrs Plane and Heathorn in 1858 to Russell & Tellyer, and then remained in the hands of the Russells until 1930, when it was bought by Truman, Hanbury & Buxton & Co. Ltd. The brewery plant was put up for sale in June 1935, with malting probably ceasing. Bottling and office operations were closed in 1987.

Russell's maltings on the opposite side of the road to the brewery consist of two ranges of multi-storey malthouses of ten bay pillar-and-panel construction in red brick. Each consisted of three growing floors supported on iron columns, and a basement level supported by jack arches, with two storage floors in the roof lit via dormer and gable end windows. There are two square kilns at the northern end, with some trace in the brickwork on the north side near the eastern kiln of a demolished addition, perhaps a malt store. An elevator tower to the loft level has also been removed. The maltings have been converted to apartments.

St Stephen's Maltings, St Stephen's Road, CANTERBURY (TR 1480 5870), is the ultimate in floor malting design, built in 1898 by Mackeson to provide malt for their brewery at Hythe. Barley obtained in Thanet could be brought to the maltings by rail to sidings at the rear of the building, where it could be hoisted via a loading lucam to storage at roof level, with malt also moved by rail to Hythe.

In design, this is a good example of what Amber Patrick has designated a Hybrid Ware multi-storey malting. It is a brick four-storey building with storage at two levels in the roof space with growing floors on three storeys, each of seven bays, measuring 72 × 78 feet. The air temperature over the growing floors was regulated in later years by a thermostatically controlled air conditioning system, with the temperature of the green

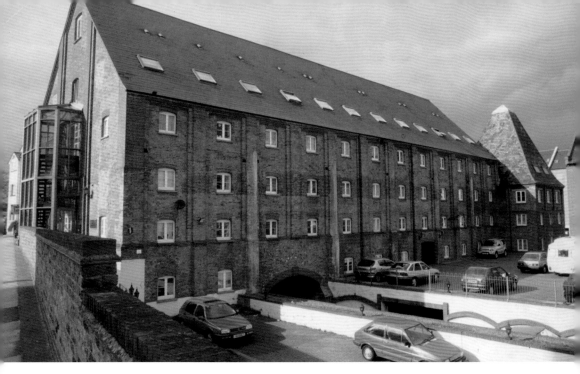

Russell's West Street malthouse from the east.

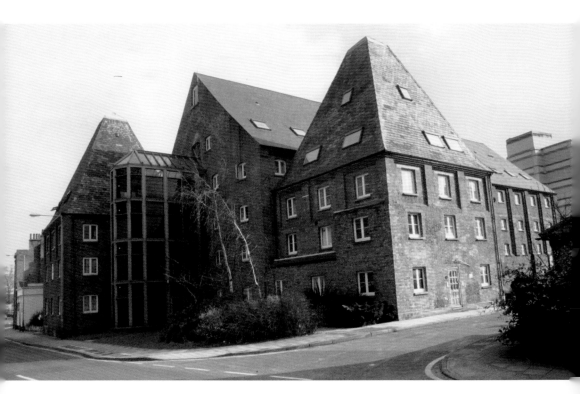

The two pyramidal kilns at the northern end of Russell's malthouse.

malt being checked every 6 hours. It has three square kilns in the centre of the building, with pyramidal roofs which were equipped with white timber cowls. The kilns had perforated tile floors and were fired with anthracite in temperature-controlled furnaces. The three lower floors are stone laid and supported on iron pillars and beams. The malt store occupied three bays to the west end of the building and consisted of twelve bins, each holding just over 300 quarters. There was an elevator ending in a tower in the roof adjacent to the kilns to carry the sprouted barley to the kilning floor. Otherwise there was little by way of mechanical handling in the malthouse with grain and malt being moved in traditional barrows, and the use of trap doors and shoots. Grain was moved as a piece in the traditional manner across the growing floor. The one exception was mechanical turners in the kilns. The other late innovations were the use of rotary screens and corn driers.

The Mackeson Brewery and malthouse became part of the Whitbread Group with the result that after 1950, St Stephen's was sending half of its malt to Whitbread's Chiswell Street Brewery, where it was rated among the best malts used by the brewery. About one eighth was sent to Wateringbury to brew 'Final Selection', with the rest going to Mackeson at Hythe. The malthouse was sold by Whitbread in 1966 to Barretts Car Sales, who cleared the kilns and interior equipment for use as a car showroom and spare parts store.

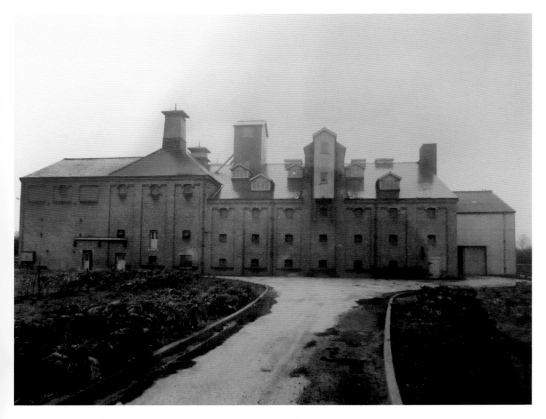

St Stephen's, Canterbury, in 1947. (Whitbread plc)

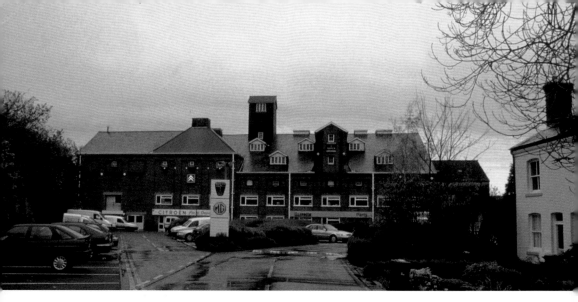

St Stephen's after alterations for use for car sales.

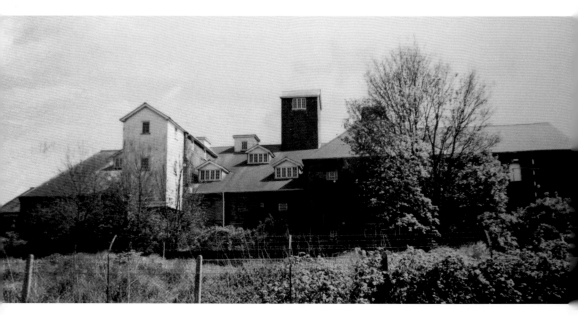

Rear of St Stephen's showing the covered lucam over the railway siding.

Although most malthouses built after *c.* 1850 show a great increase in scale, some examples were of a modest size, including that at CHALK, GRAVESEND (TQ 6657 7112). On the first to fourth editions OS, a Malthouse Farm (TQ 6670 7310) is marked in Lower Higham Road, although no malthouse is marked. A new malthouse is marked on the second edition to the west of the farm, being a two-storey malthouse of eight bays constructed in stock bricks under a slate roof. It had two square kilns (now reroofed) with a malt store

Right: The loading bay at the rear of St Stephen's after closure. (Whitbread plc)

Below: Chalk malthouse in 2002, showing the pyramidal kiln has been truncated.

beyond the kilns at the south end. The farm has been demolished, but the new malthouse remains. The malthouse is listed in Kelly until 1903 as operated by Walker & Son Ltd, who ran the Wellington Brewery in Wellington Street. The Wellington Brewery, bought by Charrington's Brewery in 1904, was closed after a fire in 1928 when malting also ceased.

A twentieth-century malthouse and oast house is identified in the Kent Historic Environment Record at Perry Court Farm, Brogdale Road, Faversham (TR 0097 6038). The building is dated to 1904, constructed of red brick under a slate roof. It consists of two square kilns at the east and one kiln at the west end with a three-storey granary or malting between. At the time the oast was built, Perry Court belonged to Lady Capel's Charity, Kew. A document in the possession of the Surrey History Centre archives (ref 4121/2/17) dated 10 June 1903 gives the tenant as John Harris Curling, who does not appear listed as a maltster although the Curling family had been associated with malting, and the purpose of the new building is given as three hop oasts and storage. It is possible that malting could have taken place here, but there is no definite information to support it.

It is possible that there are more surviving malthouses that have been stripped of any features during conversion to cottages or houses, or which were converted to hop oasts before, in the twentieth century, being converted into living accommodation.

All surviving malthouses are private property and not accessible internally, apart from three that are used commercially. Of these two, Rigden's, Faversham (now Tesco), and St Stephen's, Canterbury (now a car showroom), have been gutted while retaining their external appearance, but the Hythe malthouse, when open, still retains its slender iron supporting columns and wooden upper floor and gives some idea of how the growing floor may have looked.

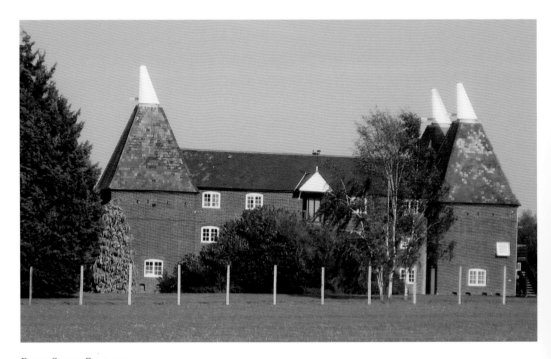

Perry Street Oast, 2011.

Bibliography

Barber, Norman, *A Century of British Brewers, 1890–1990* (Brewery History Society, 1996).

Barnard, A., *Noted Breweries of Great Britain and Ireland* (London, 1890).

Barton, T., 'St Stephen's Maltings, Canterbury' in *Traditional Buildings of Kent* (Kent County Council, 1985).

Bradford, William, *Notes on Maltings and Breweries* (1888).

Brown, J., *Steeped in Tradition; The Malting Industry in England since the Railway Age* (Reading, 1983).

Chalklin, C. W., *Seventeenth Century Kent* (Longmans, London, 1965).

Defoe, Daniel, *A Tour Through the Whole Island of Great Britain* (1724).

Ellis, William, *London and Country Brewer* (1736).

Fiennes, Celia, *The Journeys of Celia Fiennes 1685–1712* (Unknown publication year).

Hall, A. D., Russell, E. J., 'A Report on the Agriculture and Soils of Kent, Surrey and Sussex', Board of Agriculture and Fisheries, HMSO (London, 1911).

Harrison, William, *Description of England* (1577).

Hough, J. S., Briggs, D. E., and Stevens, R., *Malting and Brewing Science* (Chapman Hall, London, 1971).

Ireland, W. H., *England's Topographer or A New and Complete History of the County of Kent from the Earliest Records to the Present Time*, vol. 1 (1828).

Mingay, G., 'Agriculture' in A. Armstrong (ed.), *The Economy of Kent 1640–1914*, (Woodbridge, 1995).

Monckton, H. A., *A History of English Ale and Beer* (London, 1966).

Morrice, Alexander, *A Treatise on Brewing* (1802).

Ormrod, D., 'Industry 1640–1800', in A. Armstrong (ed.), *The Economy of Kent 1640–1914* (Woodbridge, 1995).

Osborne, K., *Bygone Breweries* (Rochester, 1982).

Owen John, 'The Malt and Malt Houses of the Shepherds', in *Master Brewer* (Shepherd Neame Ltd, April 2010).

Patrick, A., 'Establishing a Typology for the Buildings of the Floor Malting Industry', in *Industrial Archaeology Review*, vol. 18 (1996).

⁋ Patrick, A., 'Victorian Maltings in England, 1837-1914', in *Brewery History*, No. 123 (Summer 2006).

Protz, R., Sharples, S., *Country Ales and Breweries* (London, 1999).

Wade, Jane, Traditional Kent Buildings, No. 4, (1985).

Victoria County History of Kent, III, Industry. (Kent Archaeological Society, 1932)

Young, Arthur, *The Farmers Tour Through the East of England*, vols 3 and 4 (W. Strachan, London, 1771).

Directories

Baileys	British Directory, 1784.
Bagshaw	Directory of Kent, 1847.
Kelly's	Directory of Kent, 1859, 1867, 1874, 1882, 1891, 1899, 1903, 1909, 1913, 1922 and 1938.
Melville & Co.,	Directory of Kent, 1858.
Pigot & Co.	Directory of Kent, 1824 and 1839.
Simpson	Rochester, Chatham, Strood and Brompton Directory, 1865
Williams	Directory embracing the following towns: Rochester, Chatham, Brompton, Maidstone

Acknowledgements

My search for surviving malthouses resulted from reading the 'List of Unlocated Malthouses', appended to David Eve and Paul Stead's study *The Malting Industry in Kent*, which listed the results of a 1997–98 project to enhance the then *Kent Sites and Monuments Record*. A few I did manage to locate, but most have long since disappeared, hence the quest to find reasons for their demise. Of great help in research were the Kent Archive in Maidstone, which houses what remains of the Whitbread papers relating to breweries and malthouses in Kent. The Medway Archive and Local Studies Centre in Strood houses the Best brewery collection and records relating to Woodhams malthouses. I am grateful to Mr John Owen, archivist to Shepherd Neame (and author of *The Emergence of Shepherd Neame from the Earliest Days of Brewing in Faversham, 1100–1732* and *The Shepherds and Shepherd Neame Brewery Faversham, 1732–1875*), for drawing my attention to his article and allowing use of its content. Whitbread plc have kindly allowed me to use photographs housed at the Kent Archive, and the late Arthur Perceval of Faversham allowed use of some of the Standard Malthouse, Faversham. JP Heritage, Basingstoke, provided the malthouse section drawings. Other photographs, unless accredited elsewhere, are from my own collection.